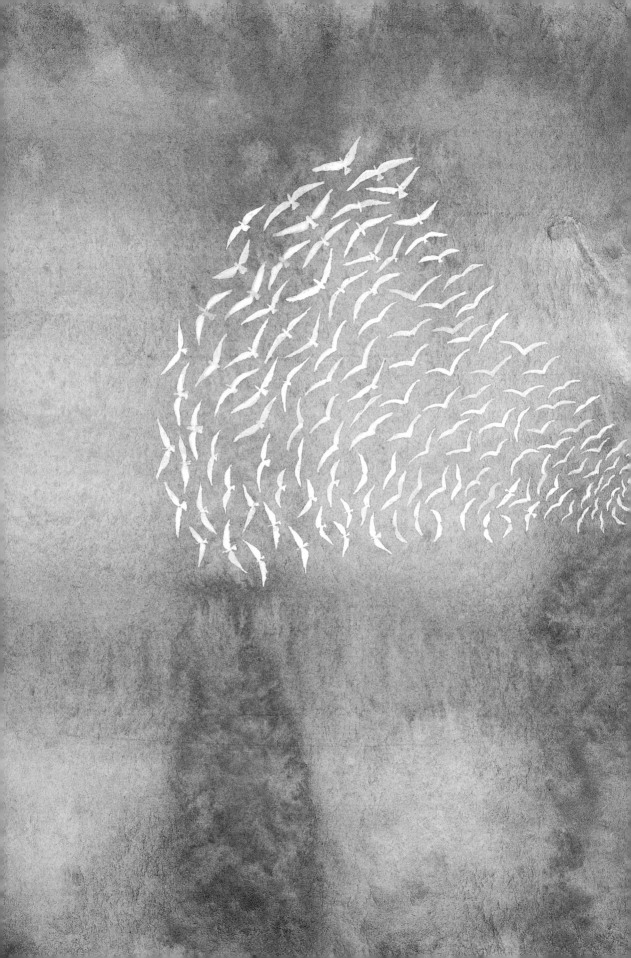

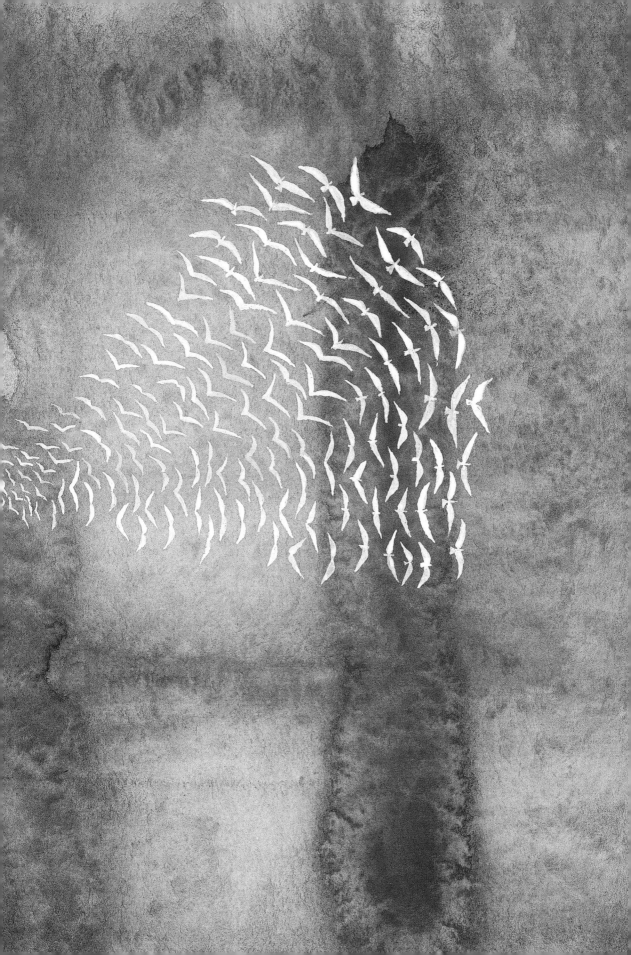

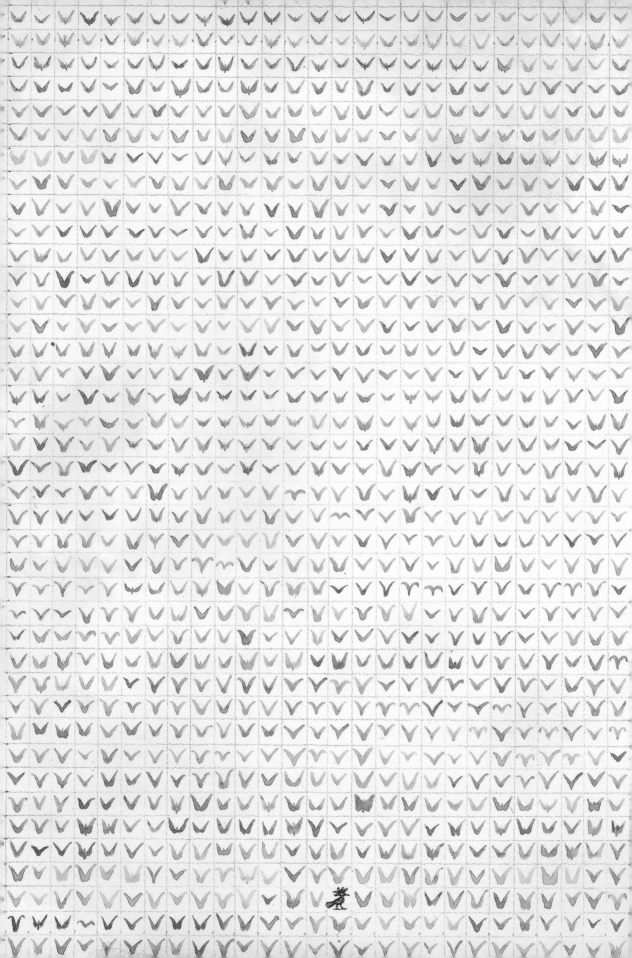

THE

CONFERENCE

OF THE

BIRDS

Peter Sís

PENGUIN BOOKS

PENGUIN BOOKS
Published by the Penguin Group
Penguin Group (USA) LLC
375 Hudson Street,
New York, New York 10014

USA | Canada | UK | Ireland | Australia | New Zealand | India | South Africa | China
penguin.com
A Penguin Random House Company

First published in the United States of America by The Penguin Press,
a member of Penguin Group (USA) Inc., 2011
Published in Penguin Books 2013

ISBN 978-1-59420-306-0 (hc.)
ISBN 978-0-14-312424-5 (pbk.)

Printed in the United States of America
1 3 5 7 9 10 8 6 4 2

Art Direction and Book Design by
Claire Naylon Vaccaro

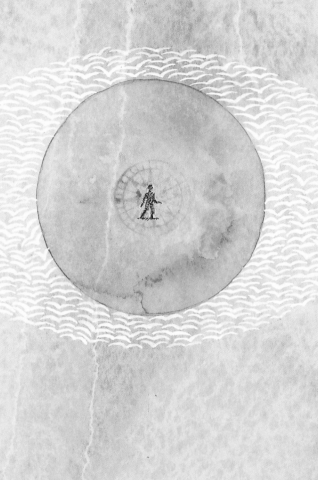

When the poet Attar woke up

one morning after an uneasy dream,

he realized that he was a hoopoe bird...

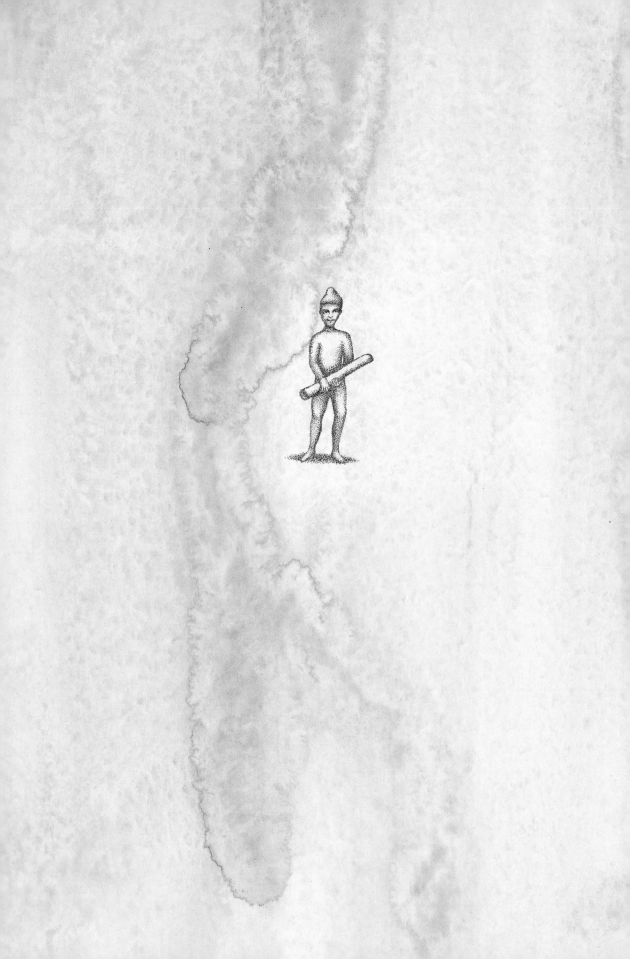

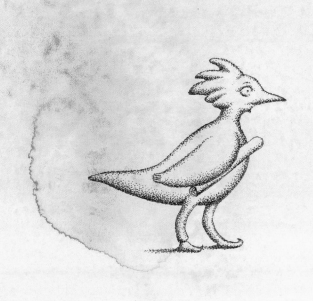

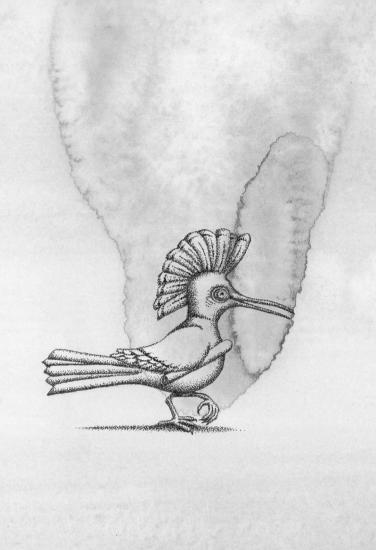

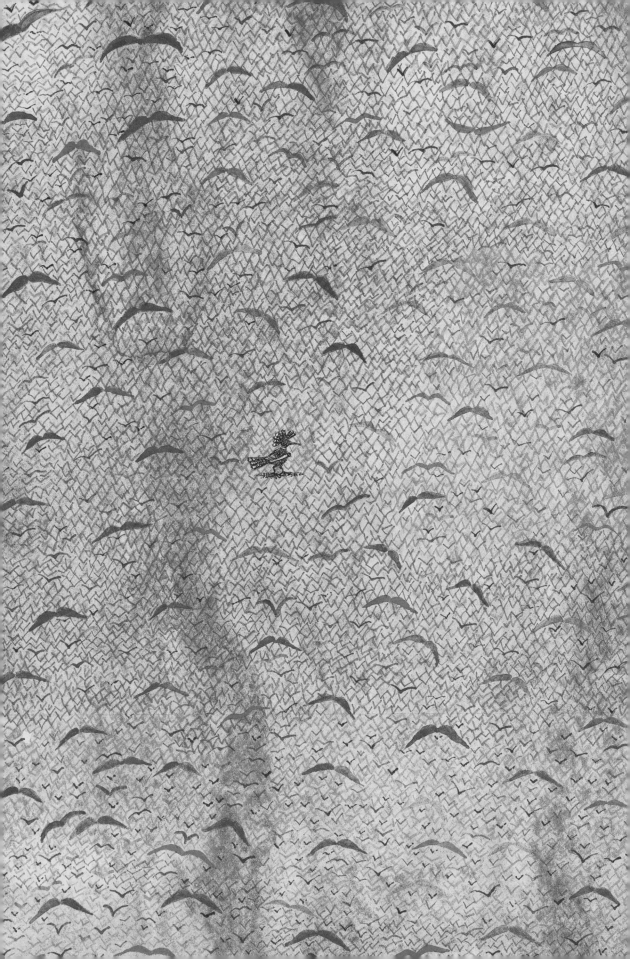

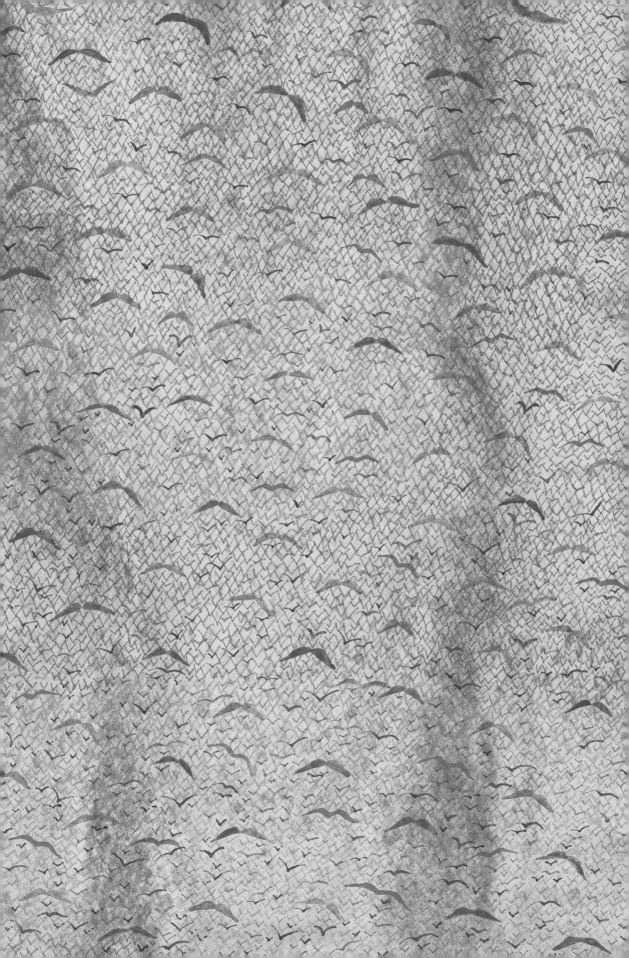

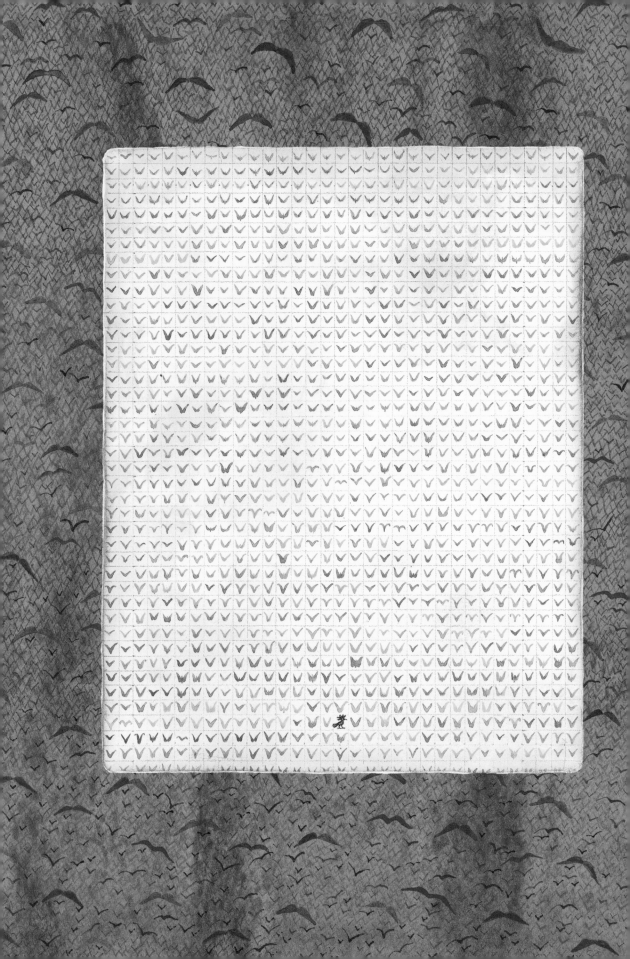

Part I

In which all the birds
of the world get together
for a conference and
are addressed by the
hoopoe bird.

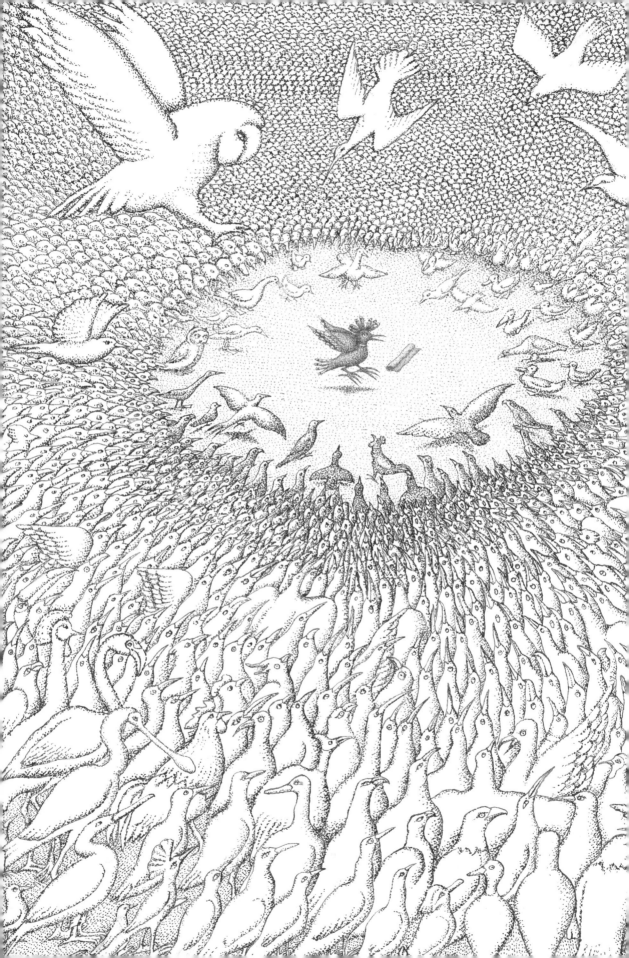

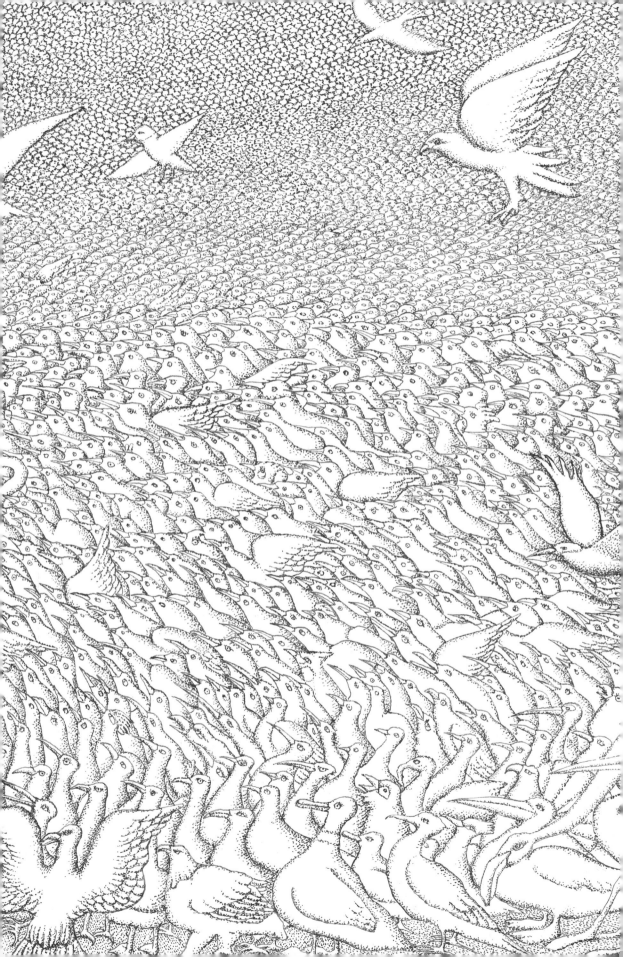

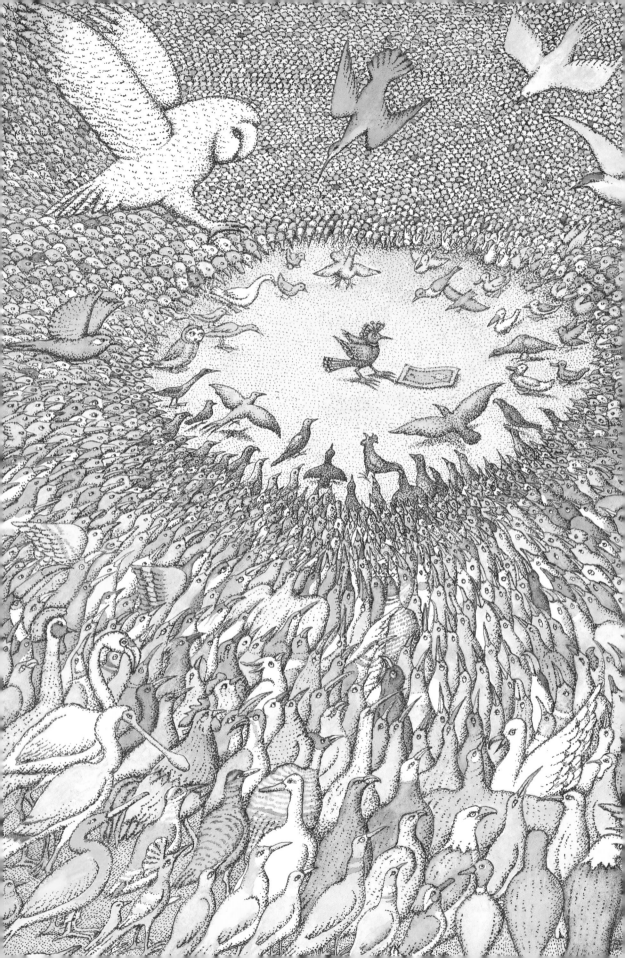

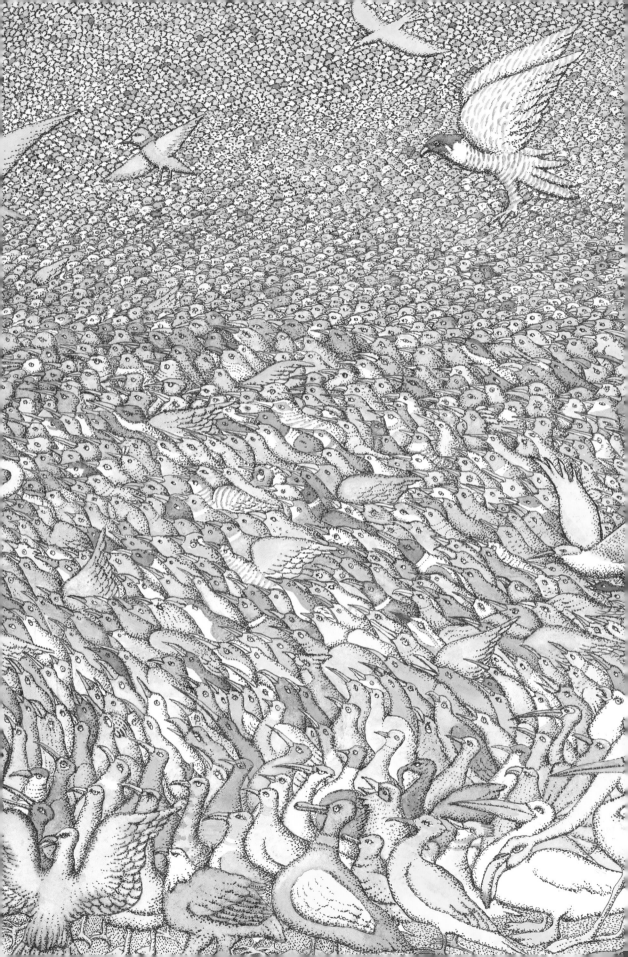

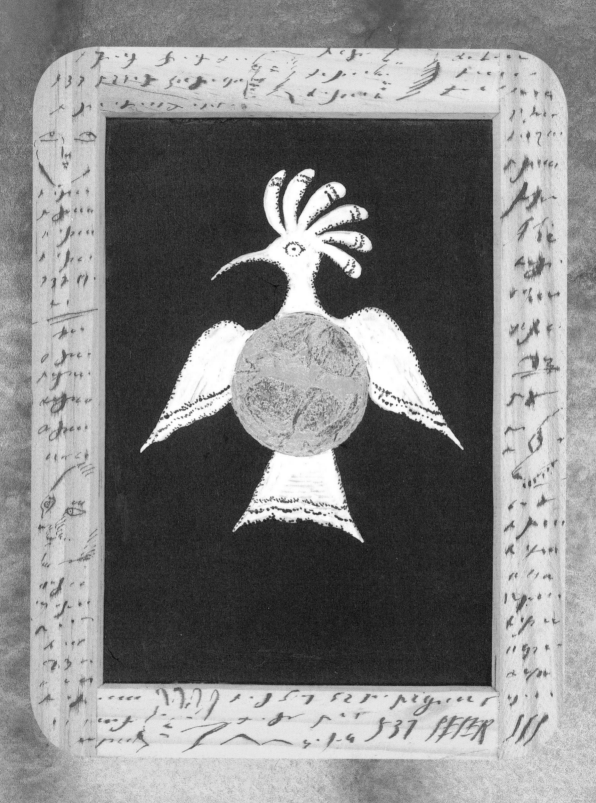

Birds!

Look at the troubles happening in our world!

Anarchy—discontent—upheaval!

Desperate fights over territory, water, and food!

Poisoned air! Unhappiness!

I fear we are lost. We must do something!

I've seen the world. I know many secrets.

Listen to me: I know of a king who has all the answers.

We must go and find him.

KINGS HAVE KINGS—WE HAD ENOUGH OF KINGS! WHAT IS THE USE OF ANOTHER KING

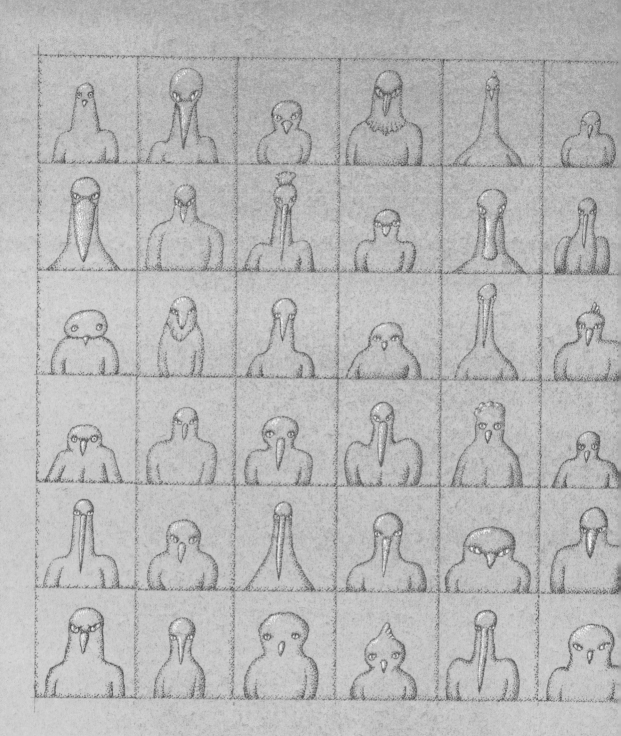

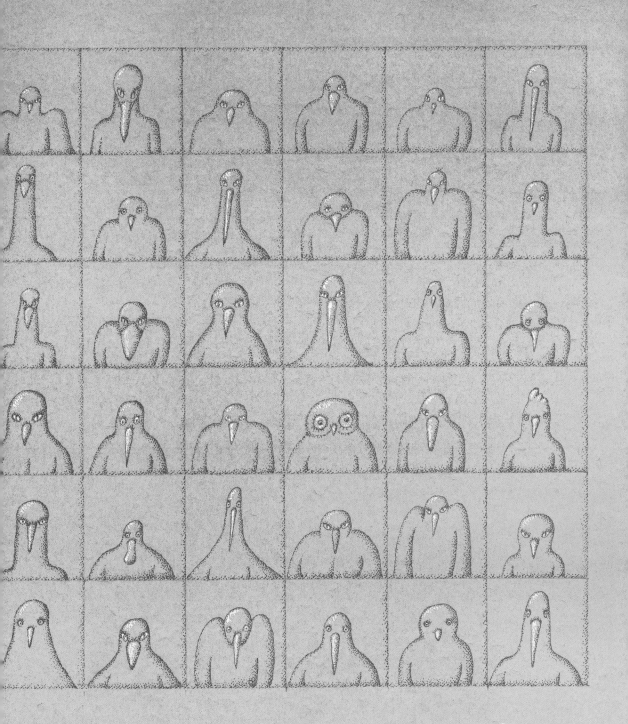

How do we know this king exists?

There's proof he exists. Look !

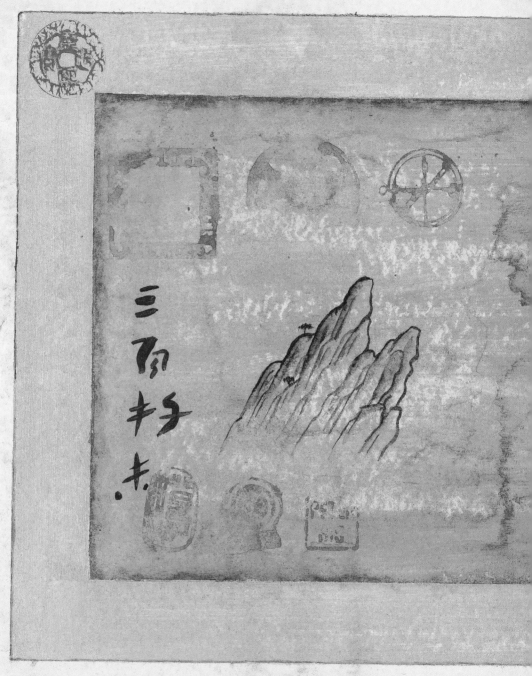

Here's a drawing of one of his feathers.

It fell to the ground in China

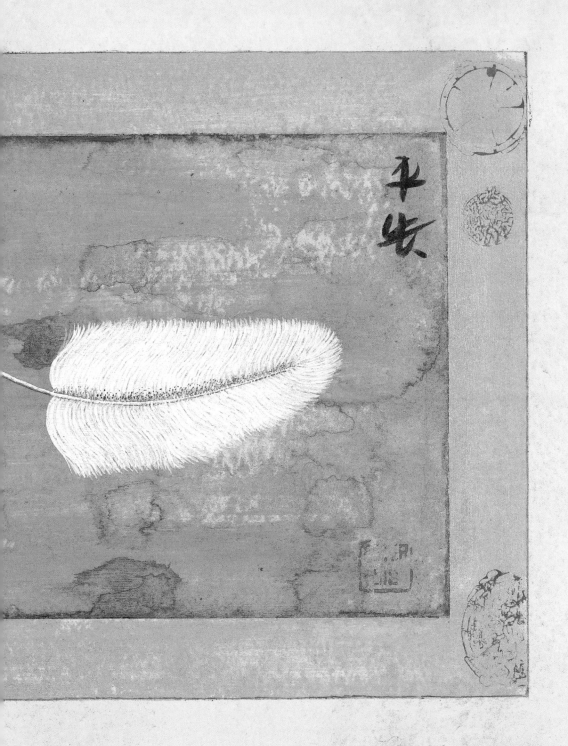

in the middle of the night.

Word got out immediately.

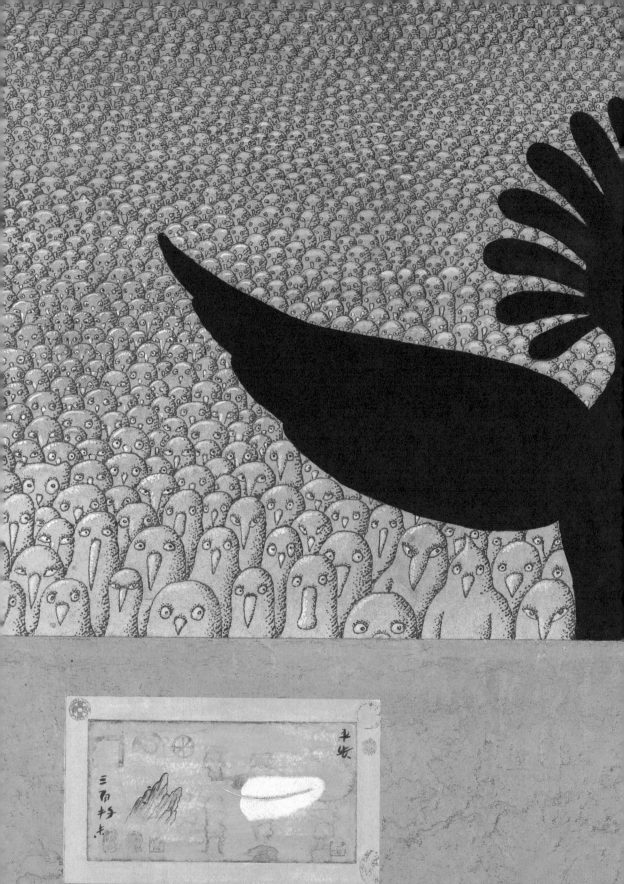

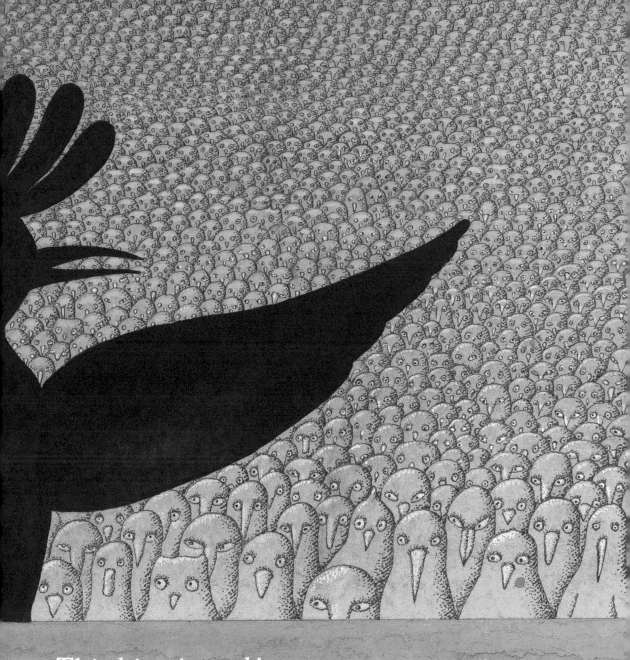

This king is real!

He is as close to us as we are far from him.

His name is Simorgh

and he lives on the mountain of Kaf.

Let us go and find him.

HOOPOE: Simorgh is hidden behind the veil of clouds.

BIRDS: What veil? What clouds?

HOOPOE: Your heart is behind the veil.

Part II

In which the birds realize
that this will be a difficult
journey and are reluctant
to give up their
comforts.

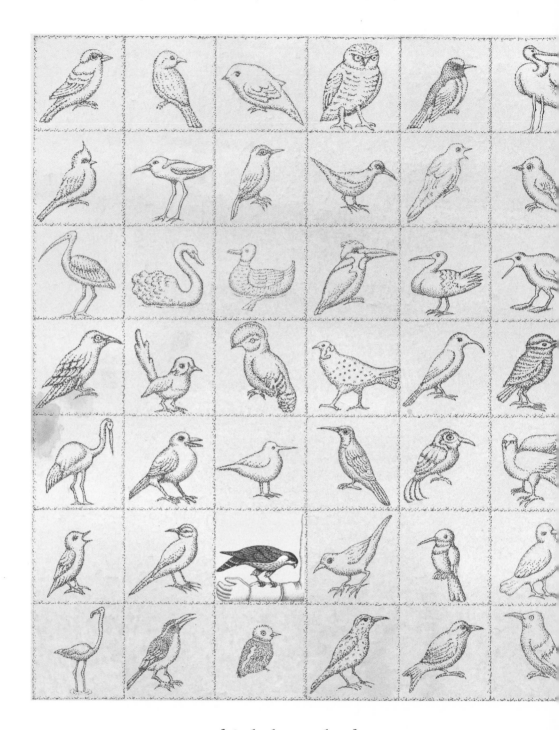

some birds have doubts

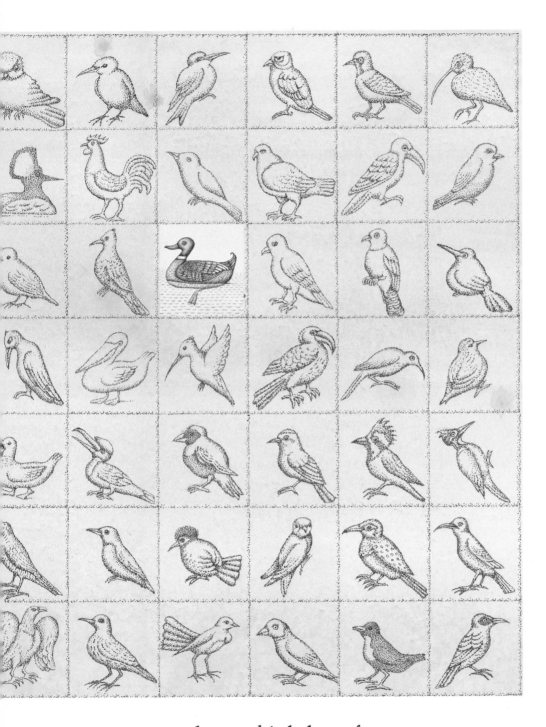

and some birds have fears

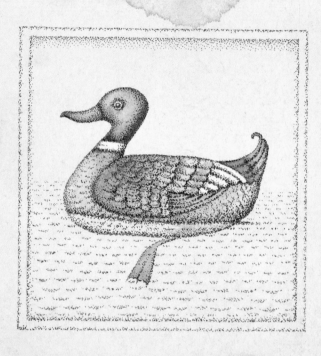

Duck : I'm happy in water !
It's the source of
everything.

 There's plenty of water where we're going.

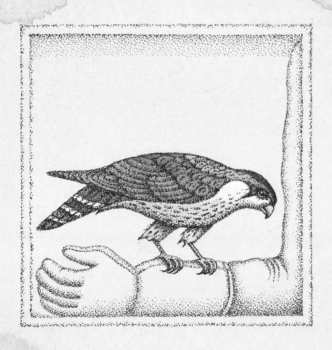

Falcon : I already

have a master !

You like following orders? Follow me !

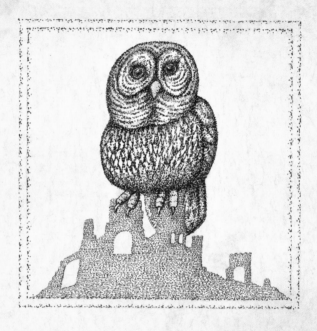

Owl : I love searching

for shiny treasure

among the ruins !

Come with us and search new places.

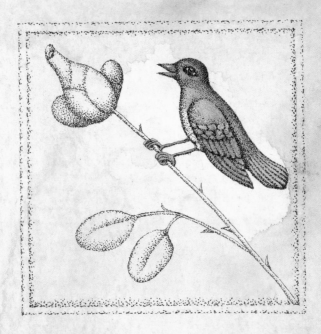

Nightingale : I live for love.

My rose and I are one.

How could I leave my rose?

Better watch for thorns!

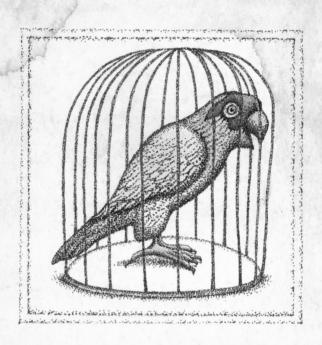

Parrot : I like it here.

I feel safe.

They bring me food

and water every day.

And tell you what to think?

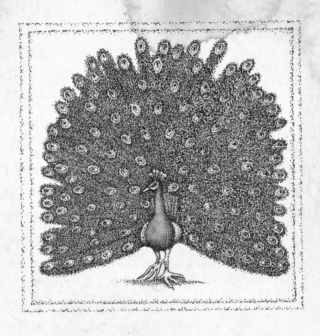

Peacock : I'm special !

I'm not like anybody else—

look at all my colors !

Come and show *everyone* your colors. Let's go !

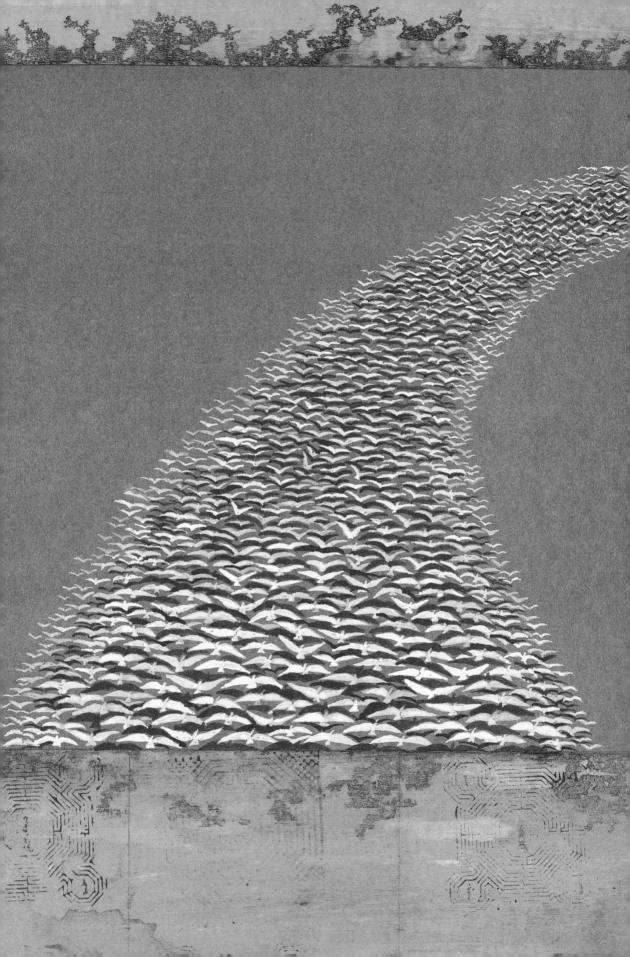

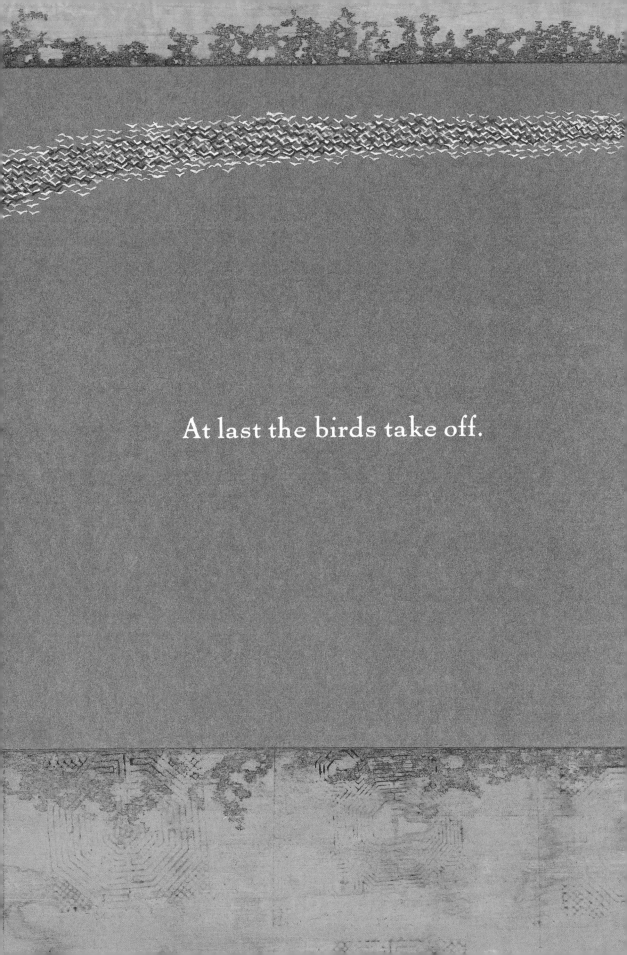

At last the birds take off.

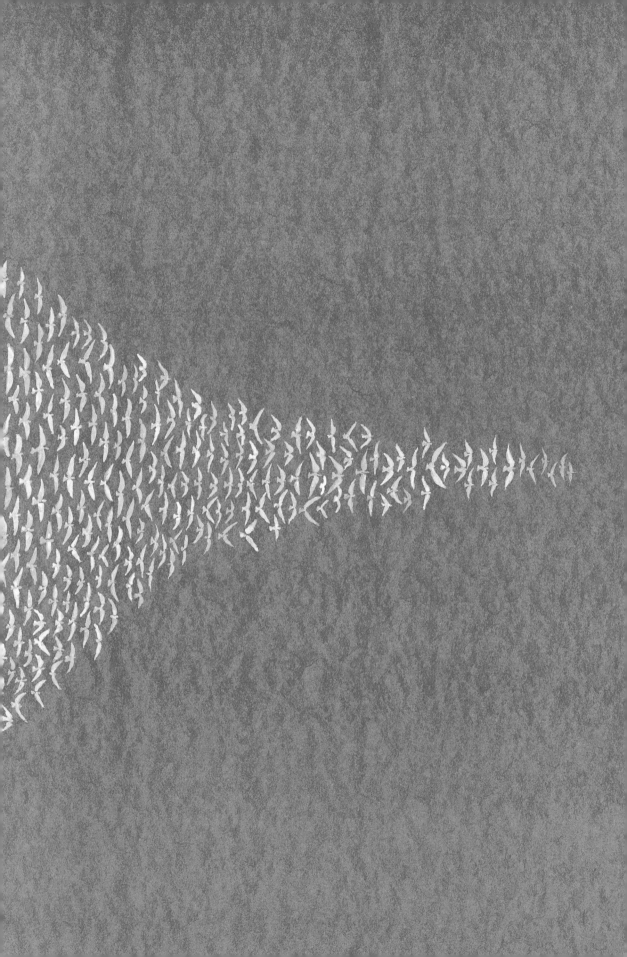

Part III

In which the birds fill all the corners of the world.

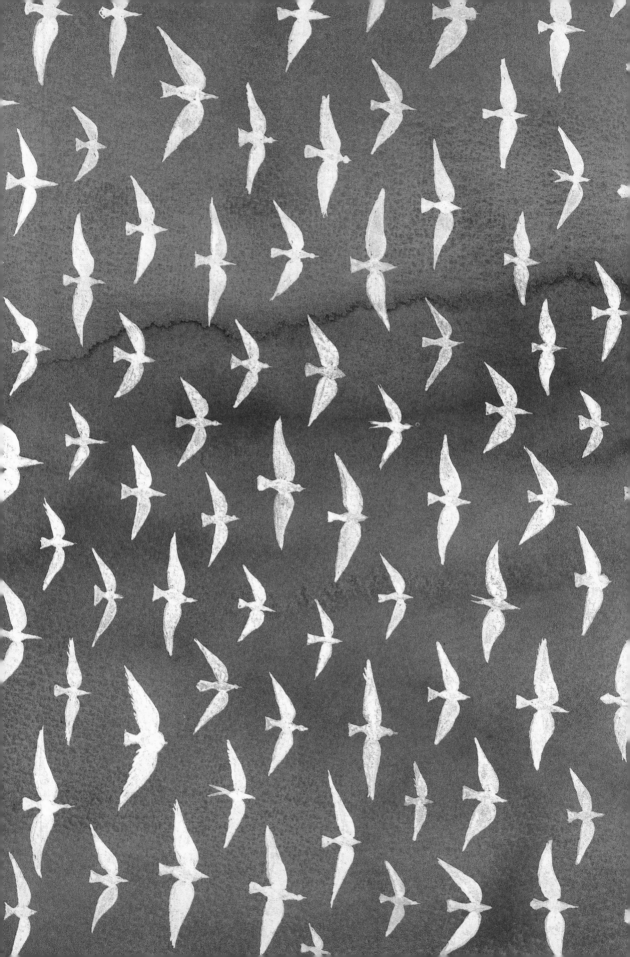

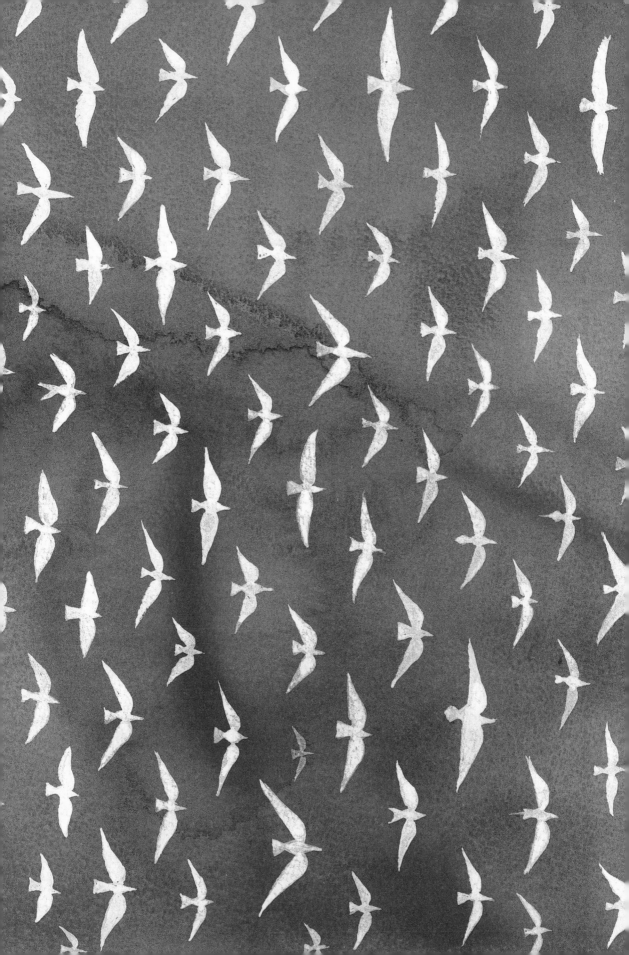

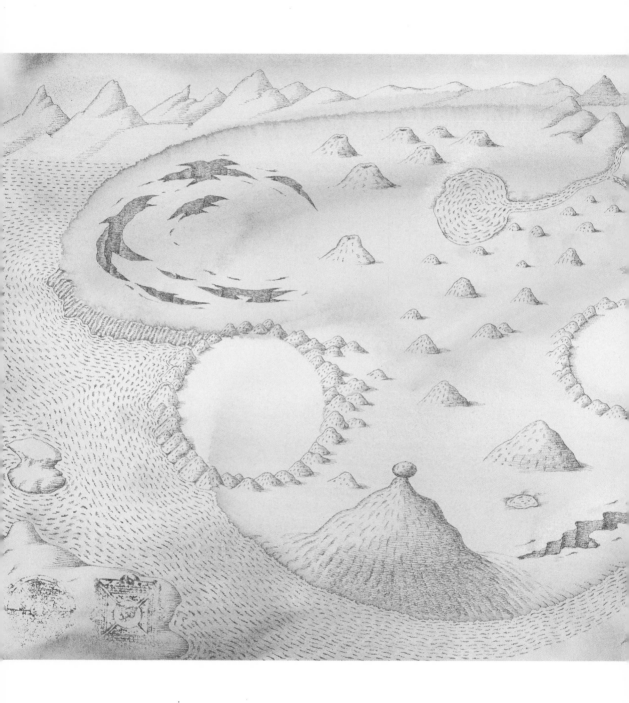

Come on, you brave birds!

Let's glide, let's fly, let's soar.

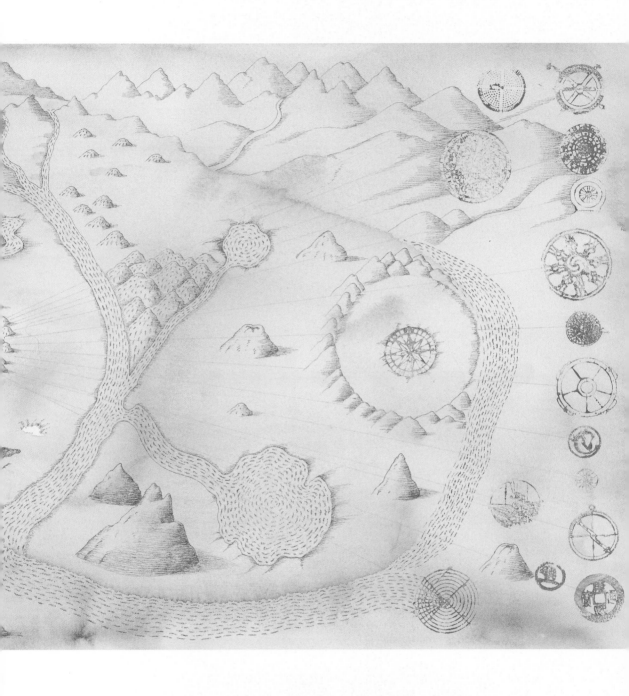

Love loves difficult things.

We're on our way!

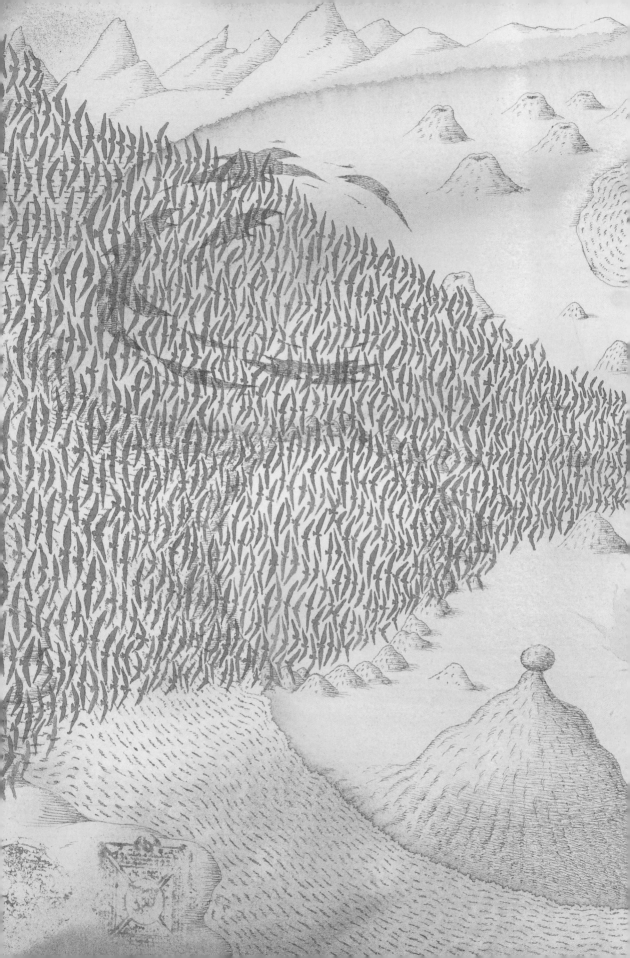

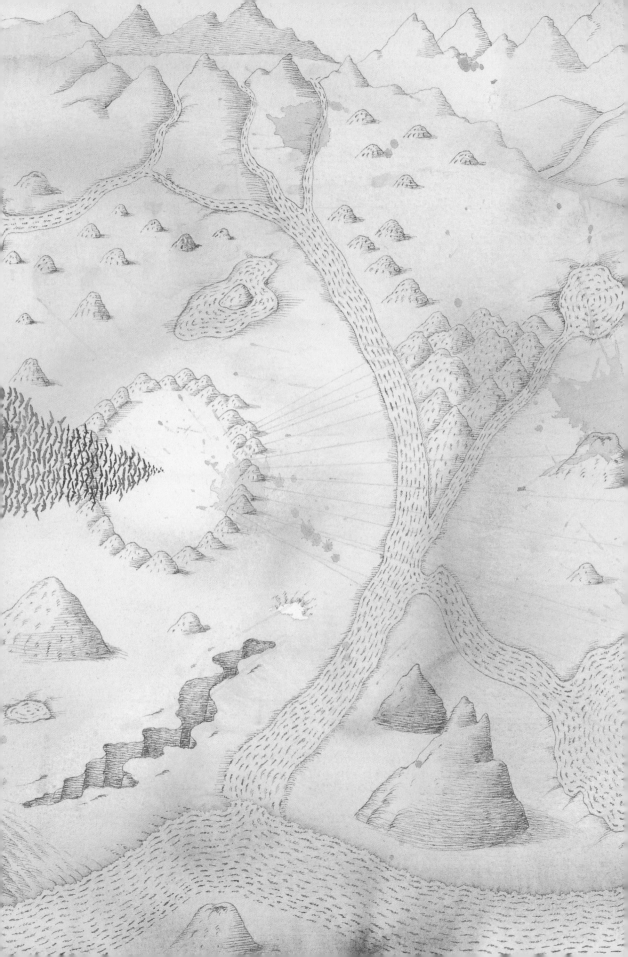

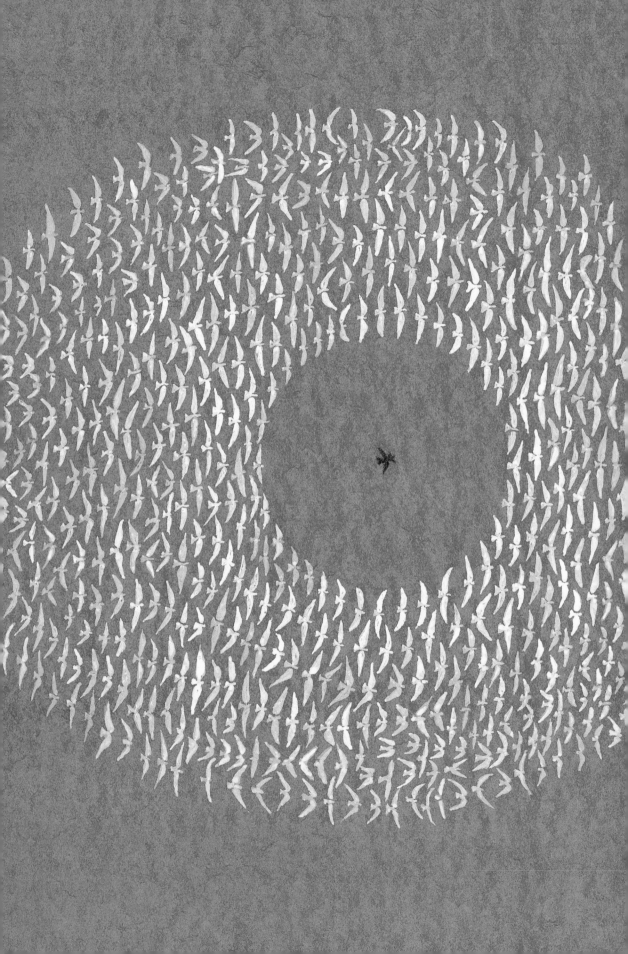

The endless deserts are crystals of sand.

The mountain ranges are a string of beads.

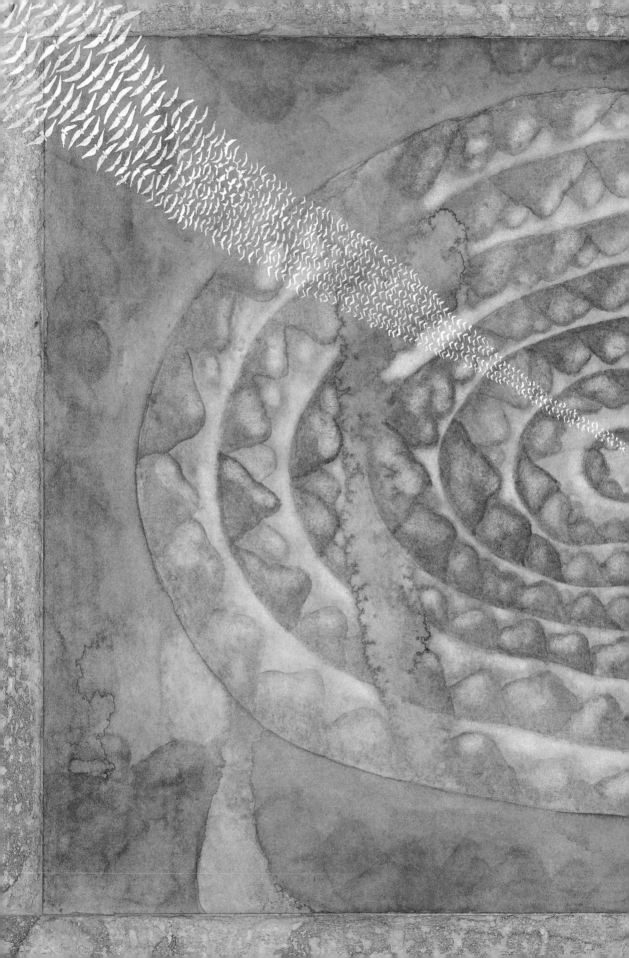

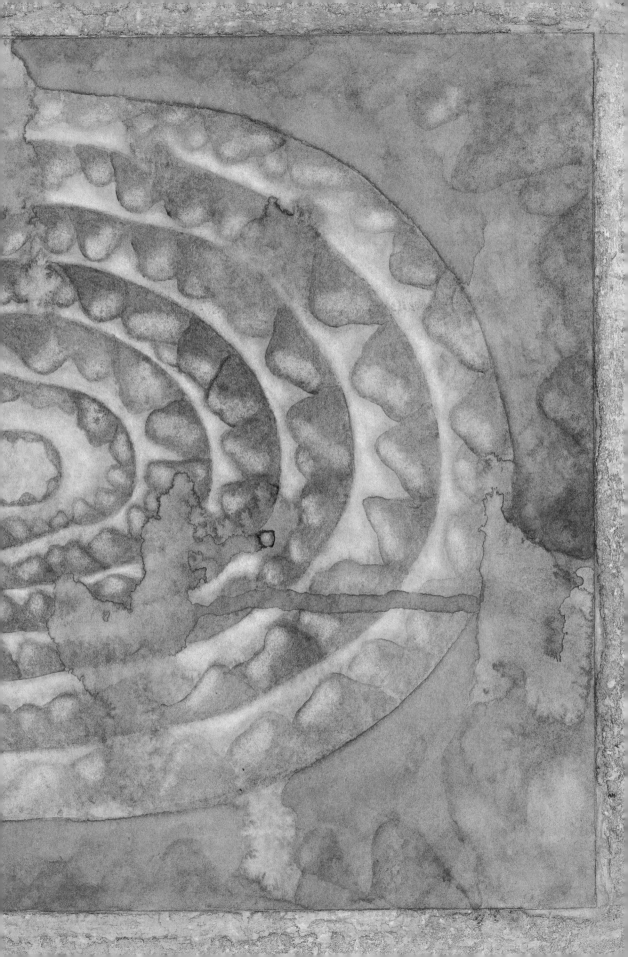

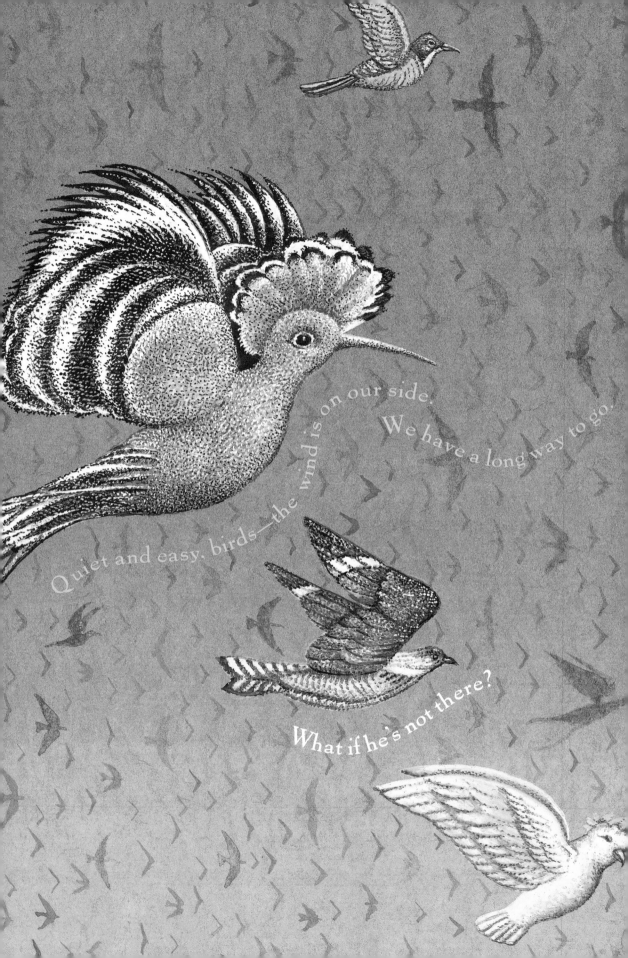

Quiet and easy, birds—the wind is on our side. We have a long way to go.

What if he's not there?

How much farther do we have to go?

I wonder what this Simorgh looks like.

Is he going to feed us?—that's what I want to know.

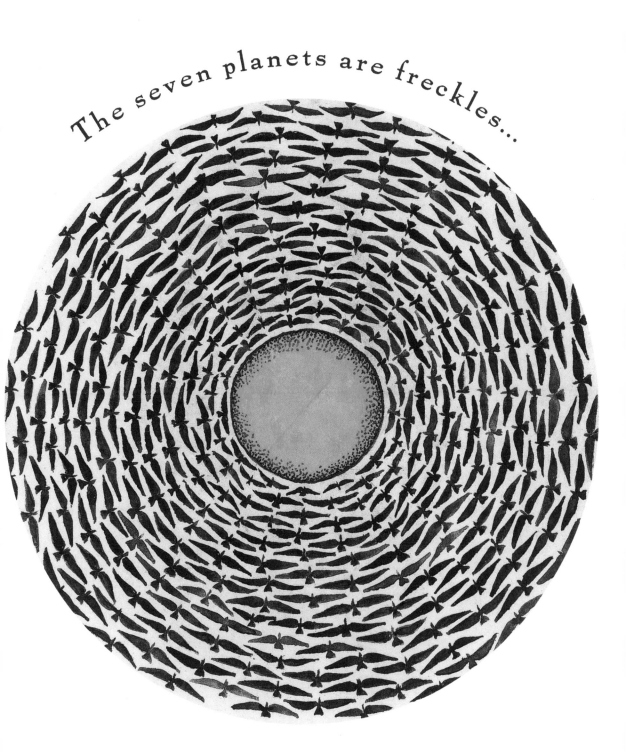

The seven planets are freckles...

The seven oceans are drops of rain...

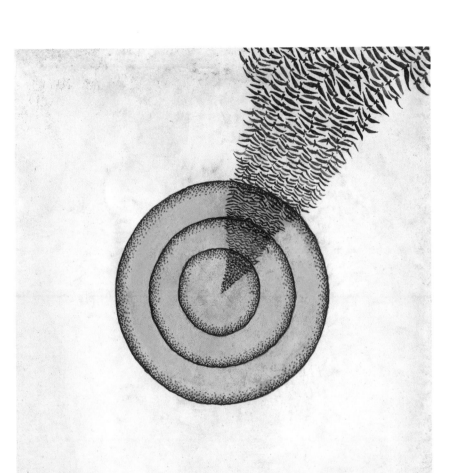

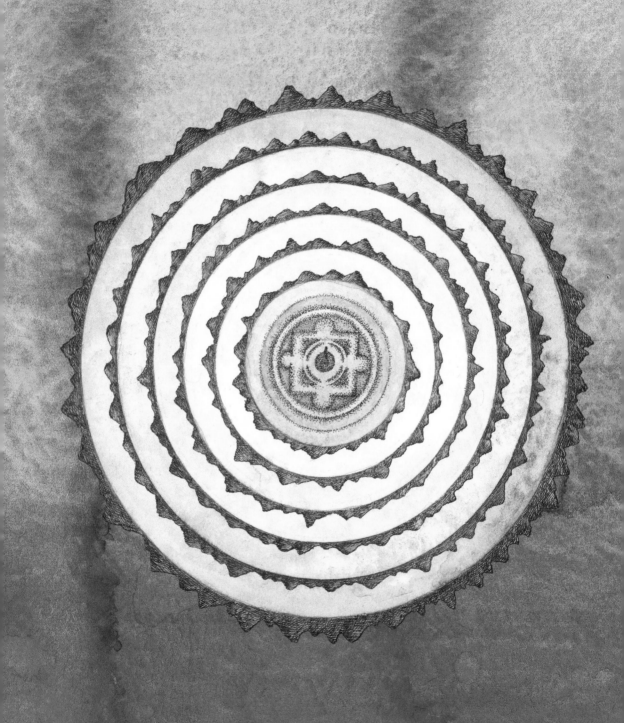

Part IV

In which the birds have to cross seven valleys.

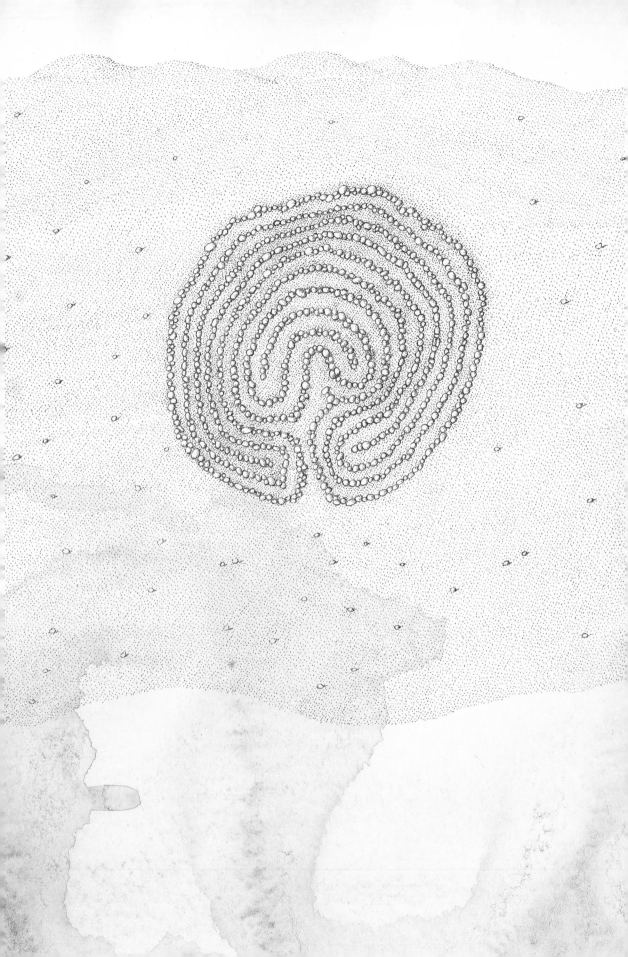

The Valley of
Quest

P peaceful

A auspicious

T truthful

I intense

E enduring

N numbing

C calming

E eternal

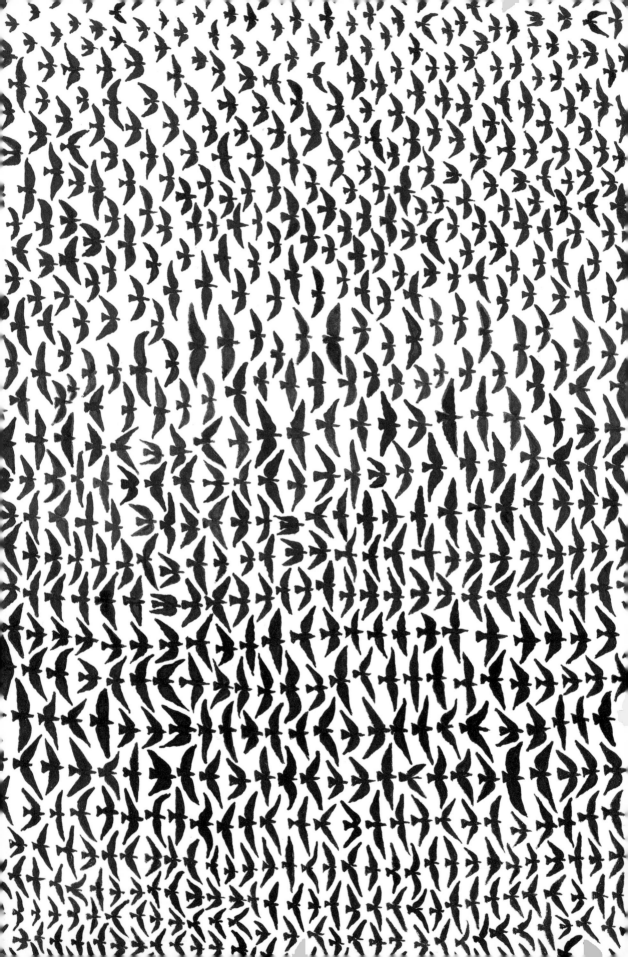

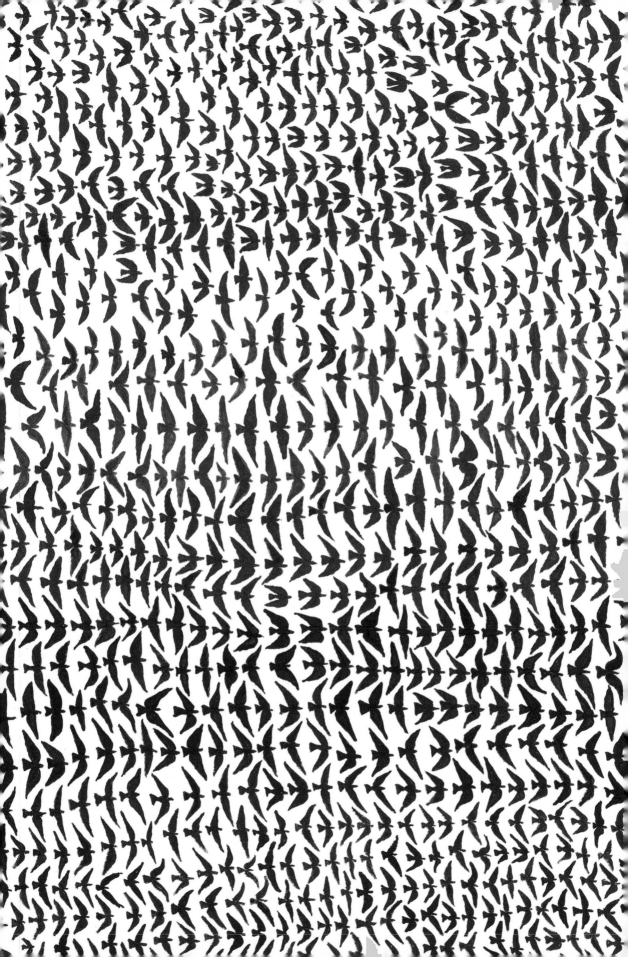

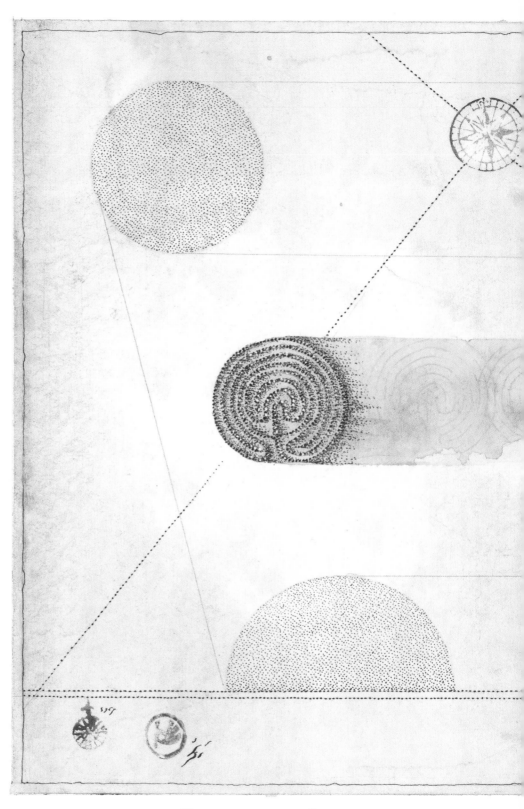

Jettison your obsessions, your power,

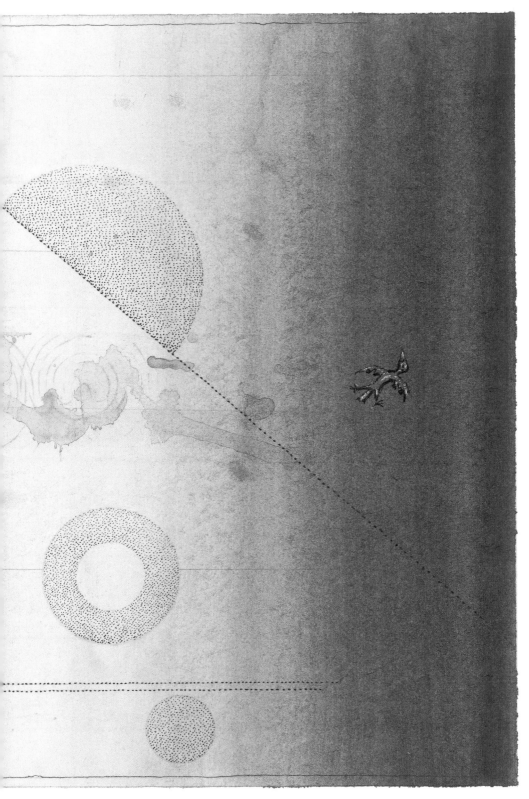

and everything you hold dear.

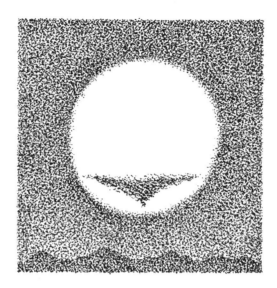

The birds settle for the night.

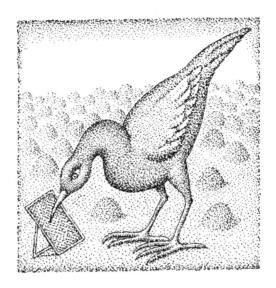

The obsessive bird, sifting the earth
through a sieve, says, I'm trying
to find my way, so I must look
everywhere.

Hoopoe: When you feel empty,
you have to open up your heart and
let the wind sweep through it.

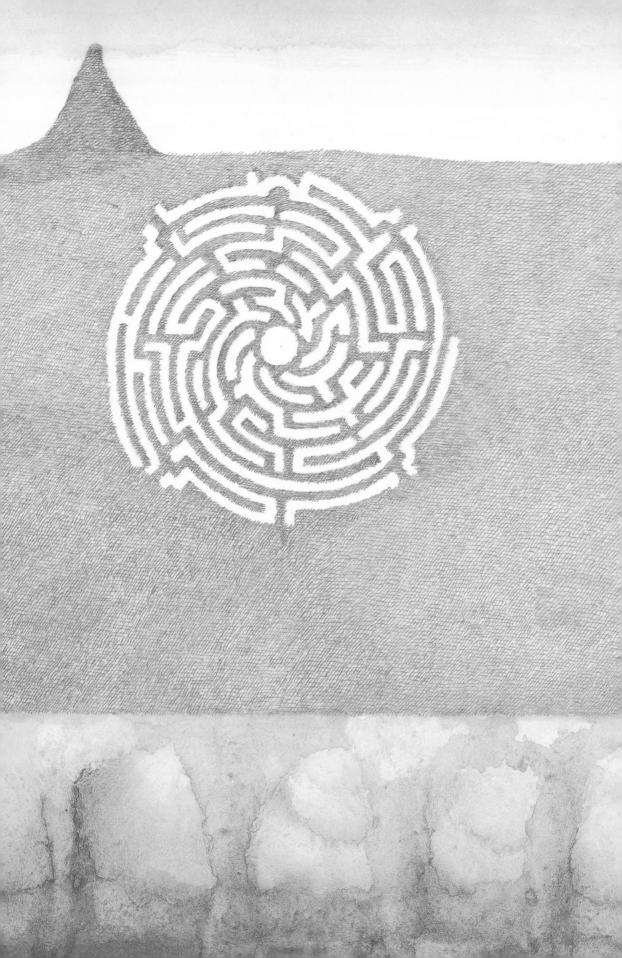

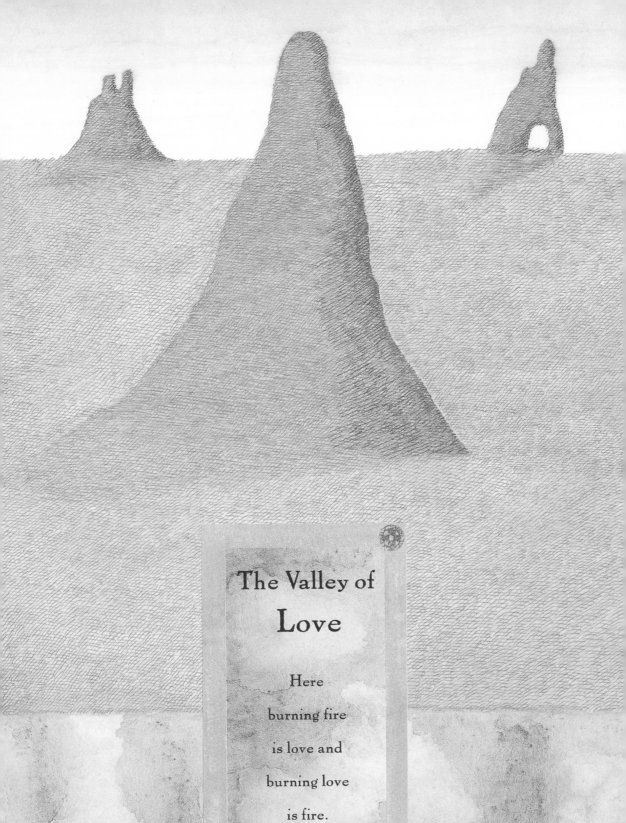

The Valley of
Love

Here

burning fire

is love and

burning love

is fire.

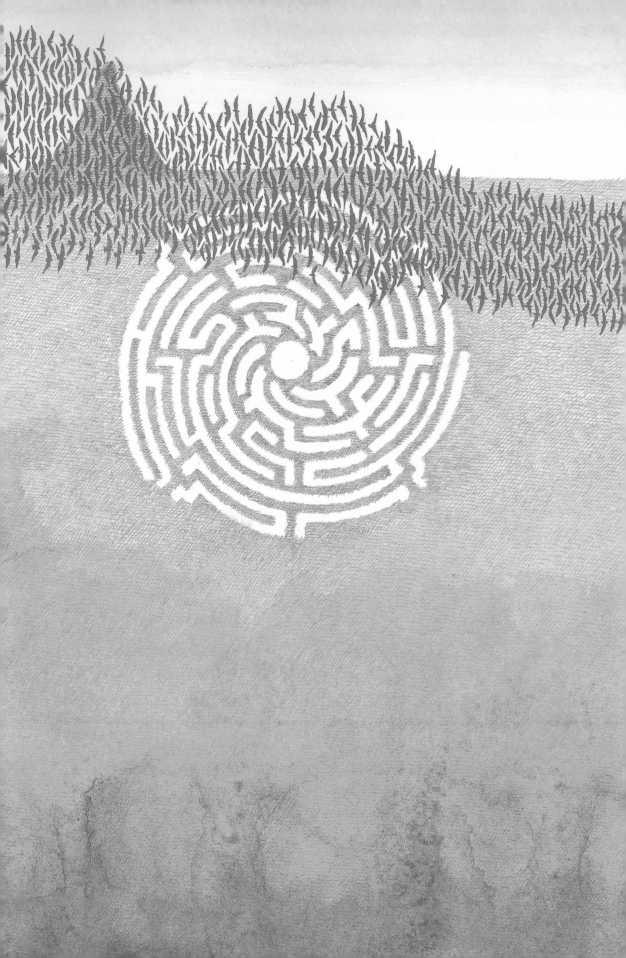

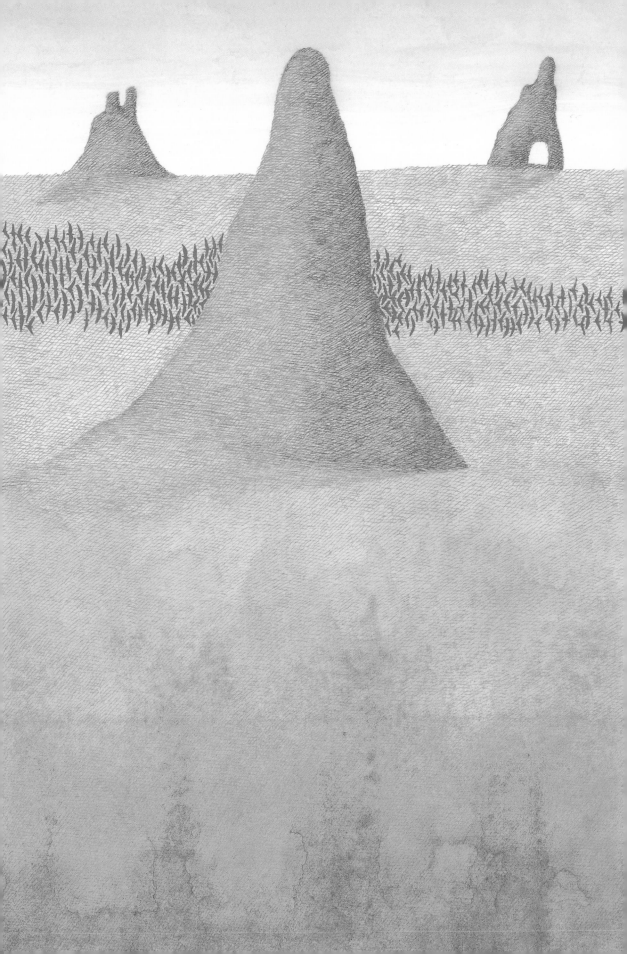

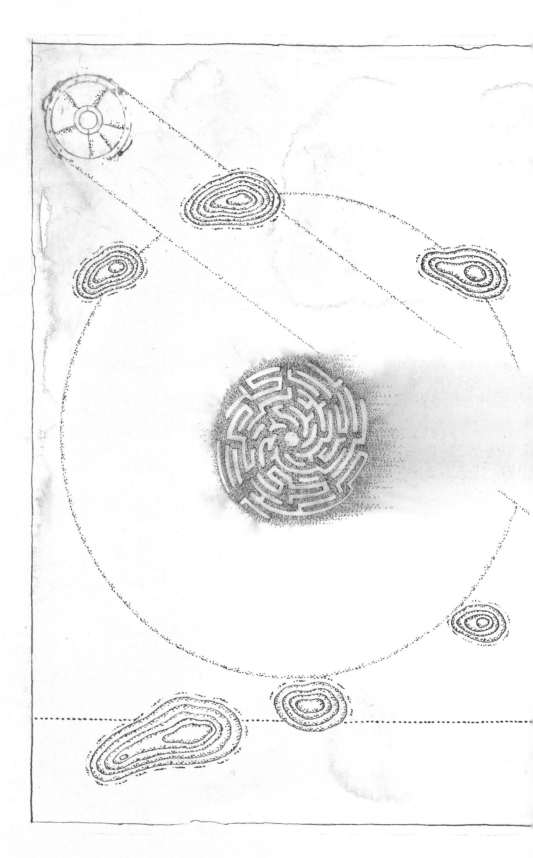

The pyre of love is…simmering and constant…

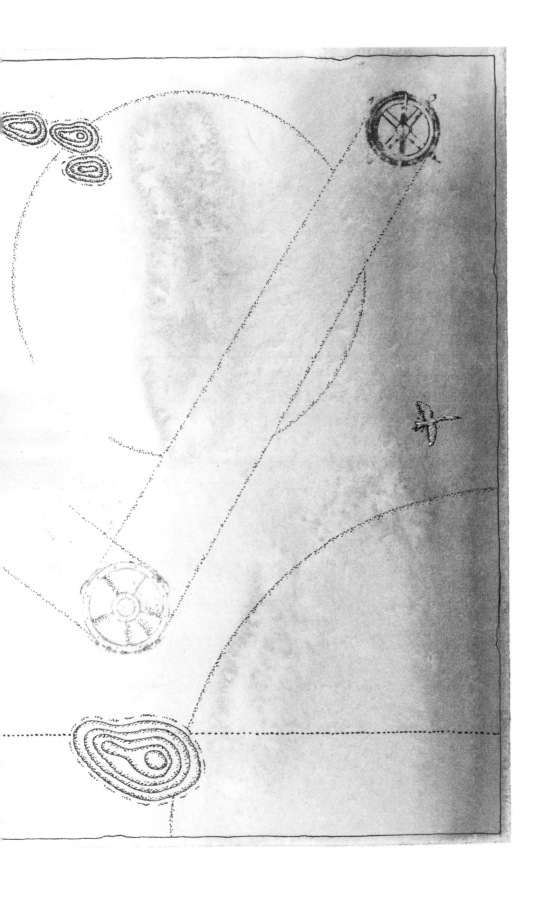

Some birds creep away under
cover of darkness.

Blushing bird: I'm scared of love.

Hoopoe: Love can lift you to
the top of the world or pull you
to the bottom of hell.

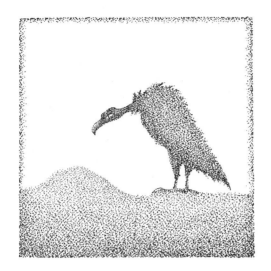

Hoopoe: The ancient gravedigger
was asked if you can bury love.

He answered that he had buried
many corpses over many years but
had never once buried his desires.

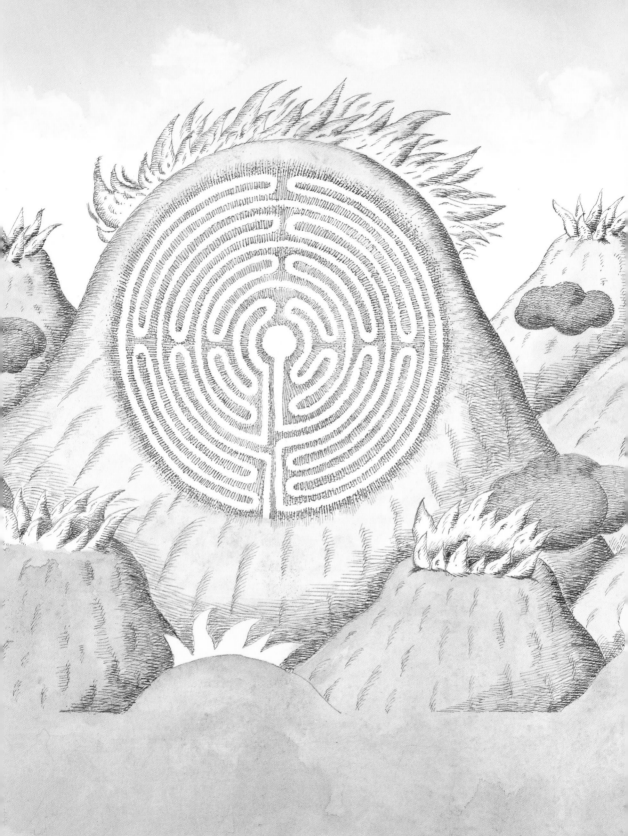

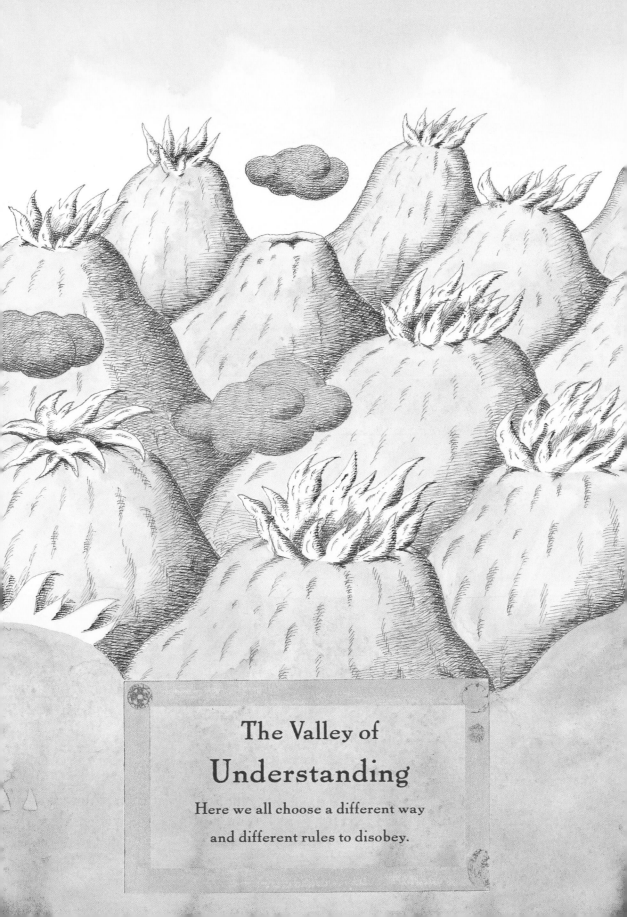

The Valley of

Understanding

Here we all choose a different way
and different rules to disobey.

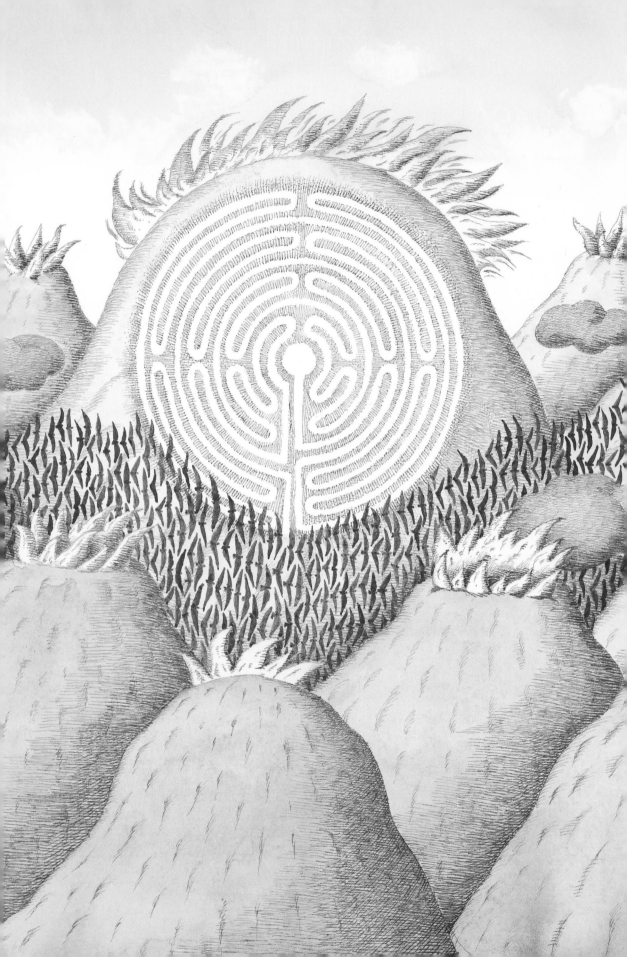

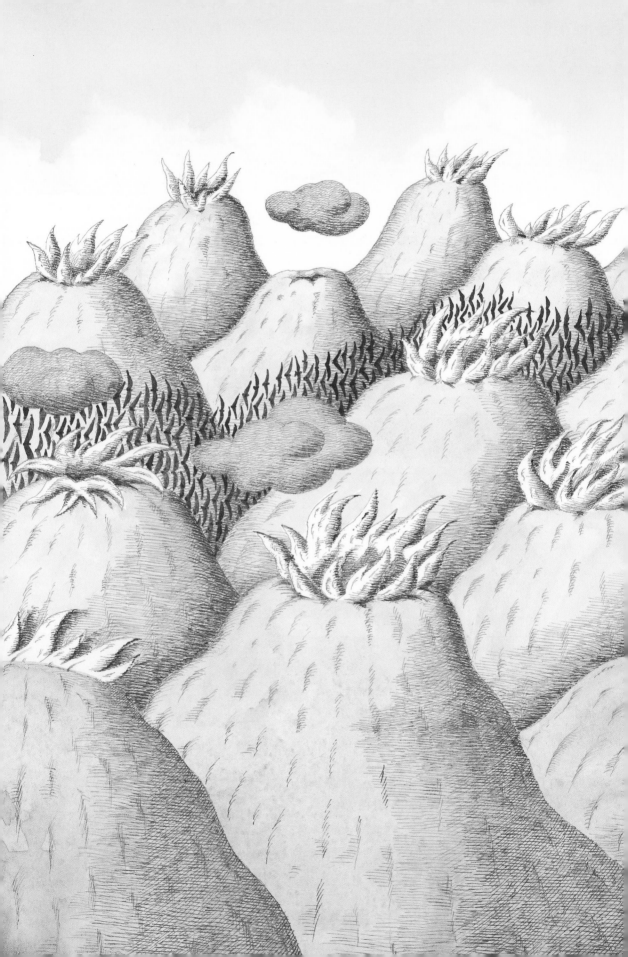

With time suspended, there is no beginning

or end, only endless flight.

Birds: Where are we?
There's no understanding in this
Valley of Understanding.

Hoopoe: Here we must pay
close attention. We are following a
path. No one knows how long we
have to go forward or how far.

Do you know the story of the bird
who lost his way? And nobody
was looking for him?
He turned into stone…and cried.
He cried little pebbles…

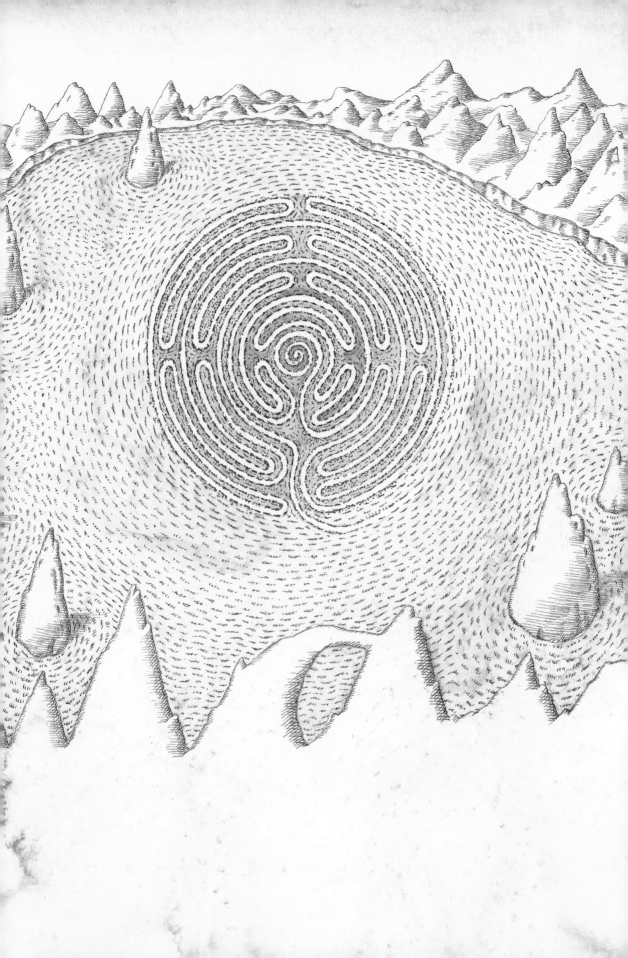

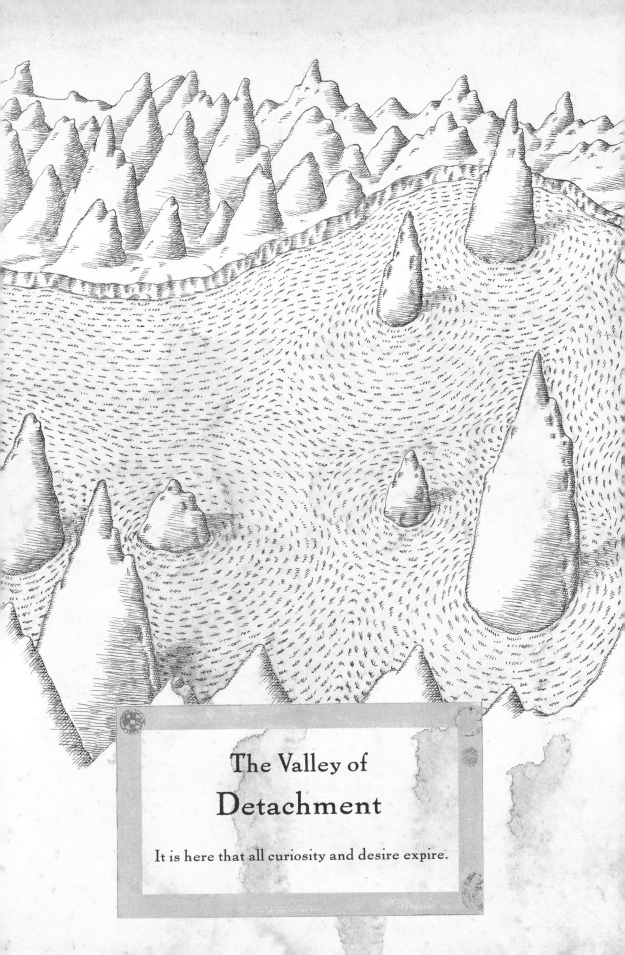

The Valley of
Detachment

It is here that all curiosity and desire expire.

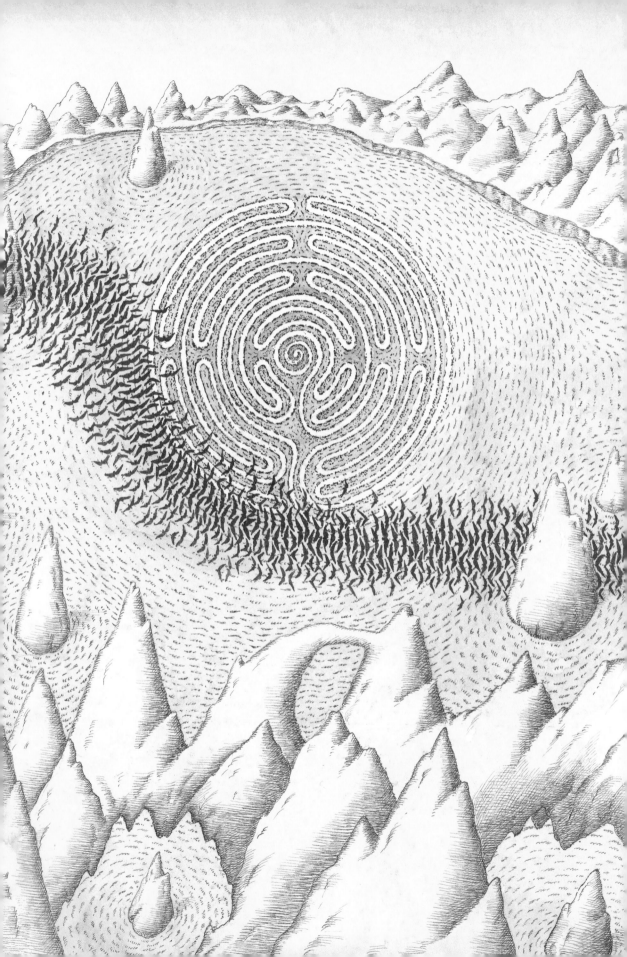

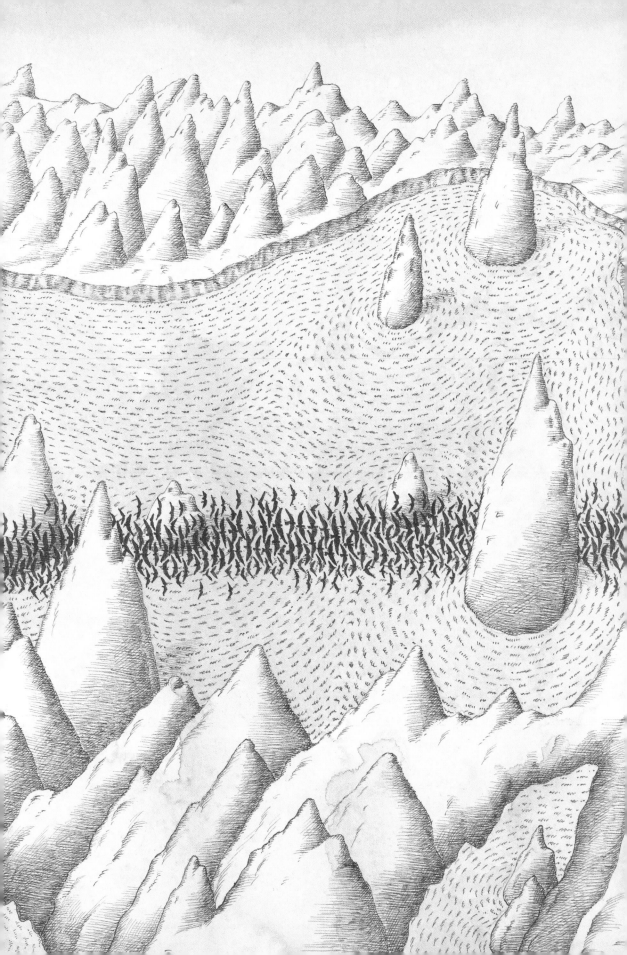

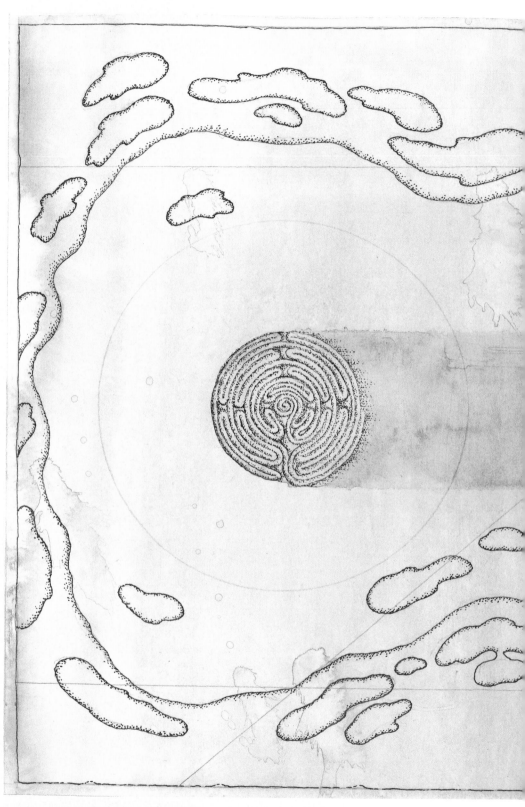

Howling, a tornado surges suddenly out of

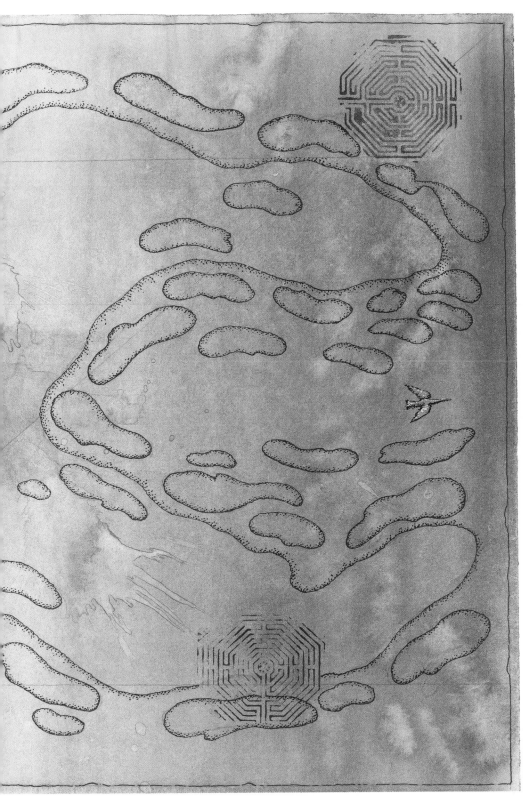

nothingness and lays waste entire continents.

If all the heavens with all their stars
exploded in this valley, they would
be but a leaf fluttering in the wind.
Here a tiny fish is mightier than
a whale and nobody can say why.

The astrologer bird traces all
the constellations and planets on
his tablet of sand.
Then the wind picks up and...
scatters his design to dust.

How solid is our world...
and yet it is nothing but grains
of sand.

Hoopoe: Do not even think
about stopping here, birds.

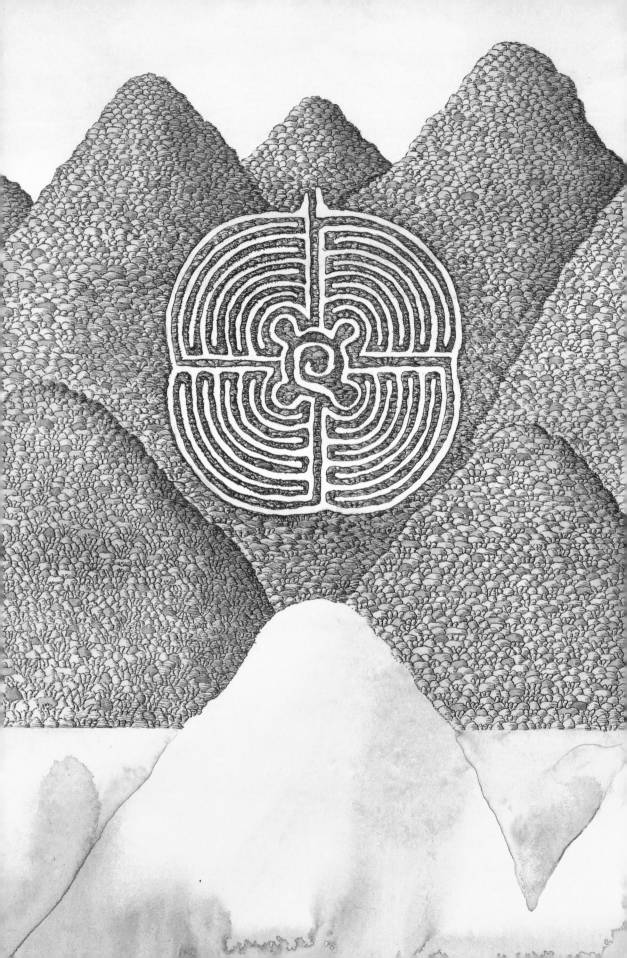

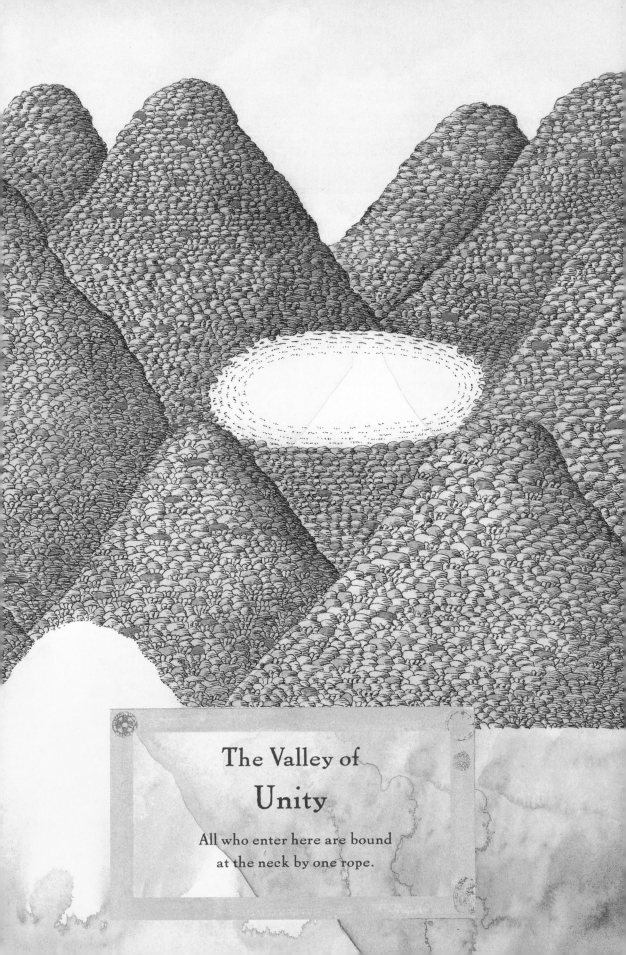

The Valley of
Unity

All who enter here are bound
at the neck by one rope.

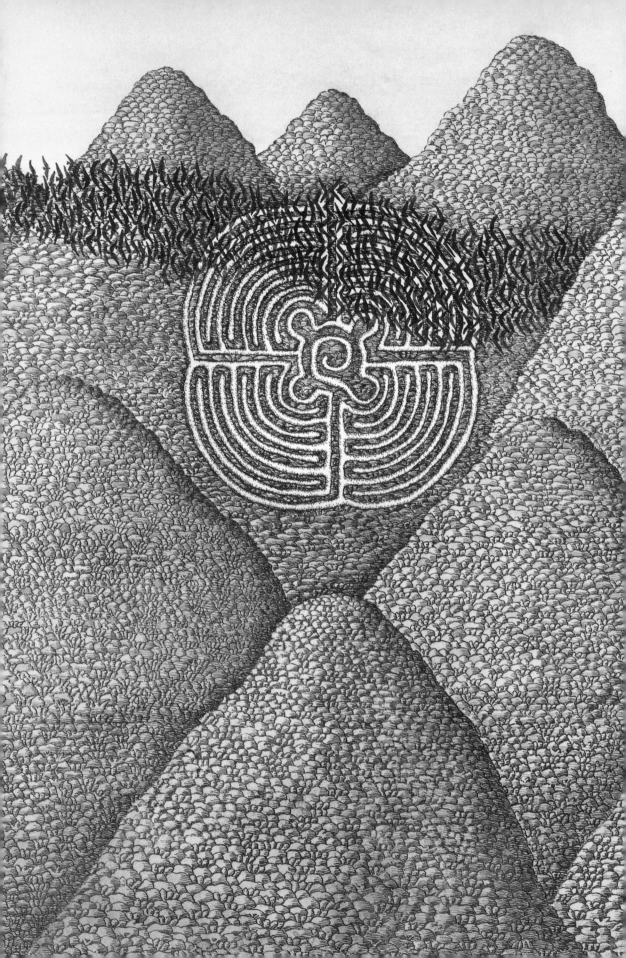

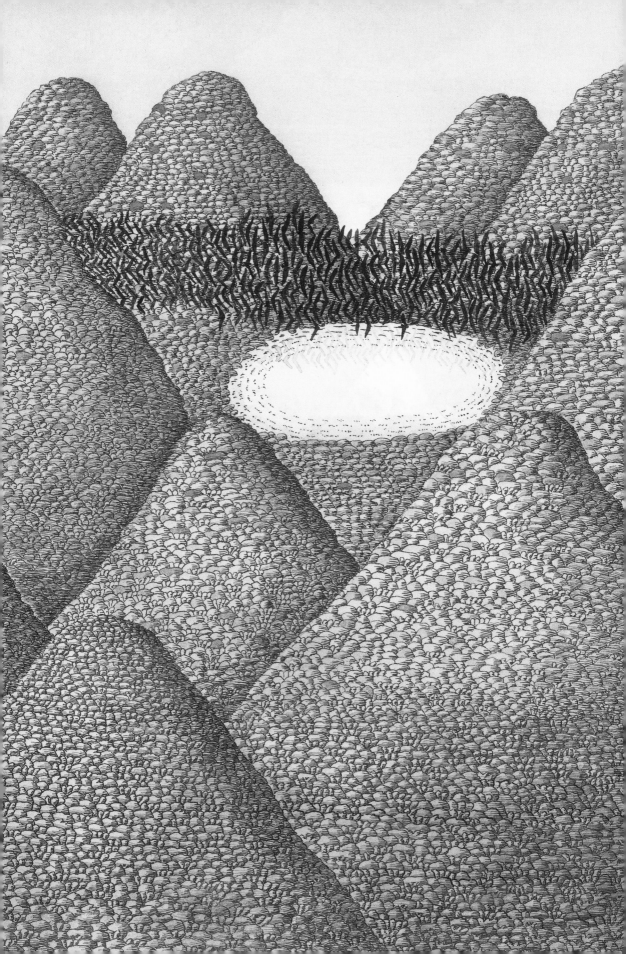

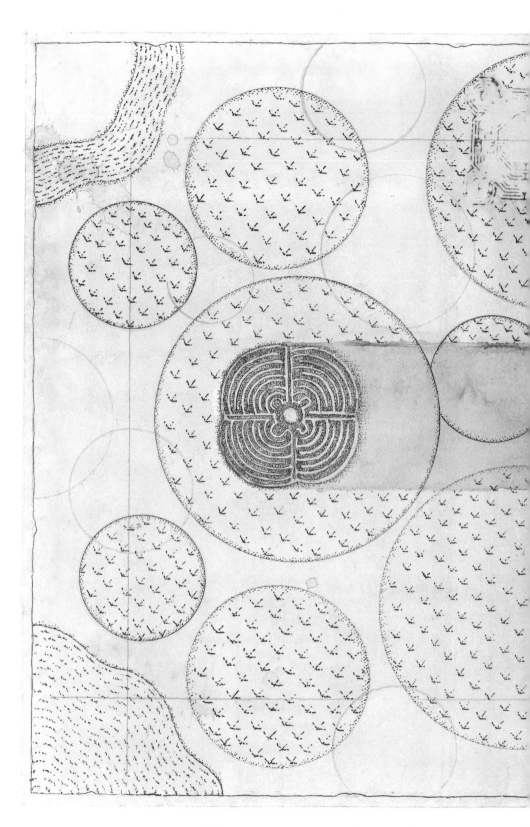

If you see many here, they are in

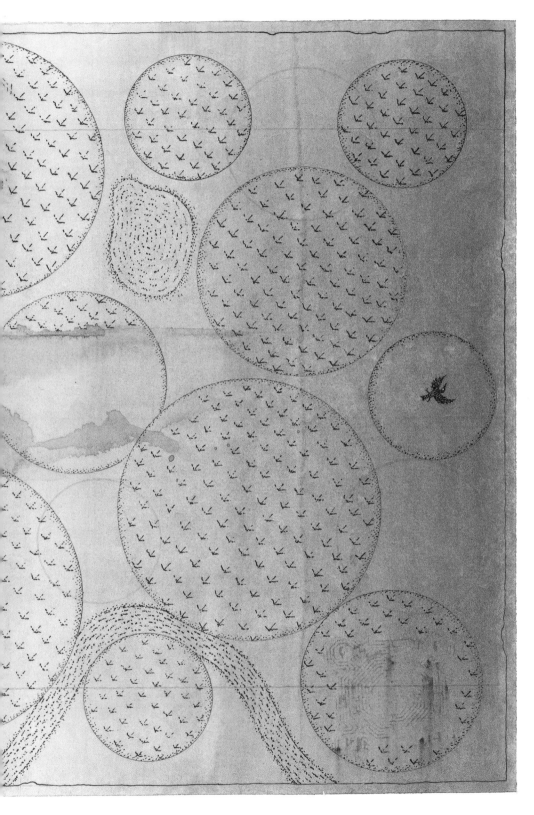

reality only a few...if any.

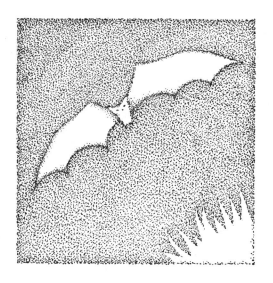

As the exhausted birds drop off to
sleep, a bat appears.

Bat: What news do you have
of the sun? I've been flying in
the dark my whole life.
I can't find the sun.
Does the sun even exist?

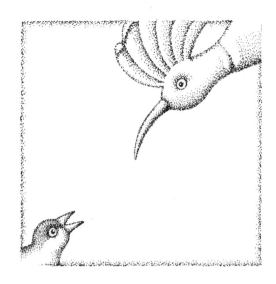

Hoopoe: Why aren't you asleep, tiny bird? We all need our rest.

Tiny bird: I'm never sure of myself. One day I'm confident and the next day I'm uncertain. One day I despair, the next day I soar. I'm weak, I'm frail. I just...never...fit.

Hoopoe: Everyone has ups and downs, little bird. Fly...clean your heart.

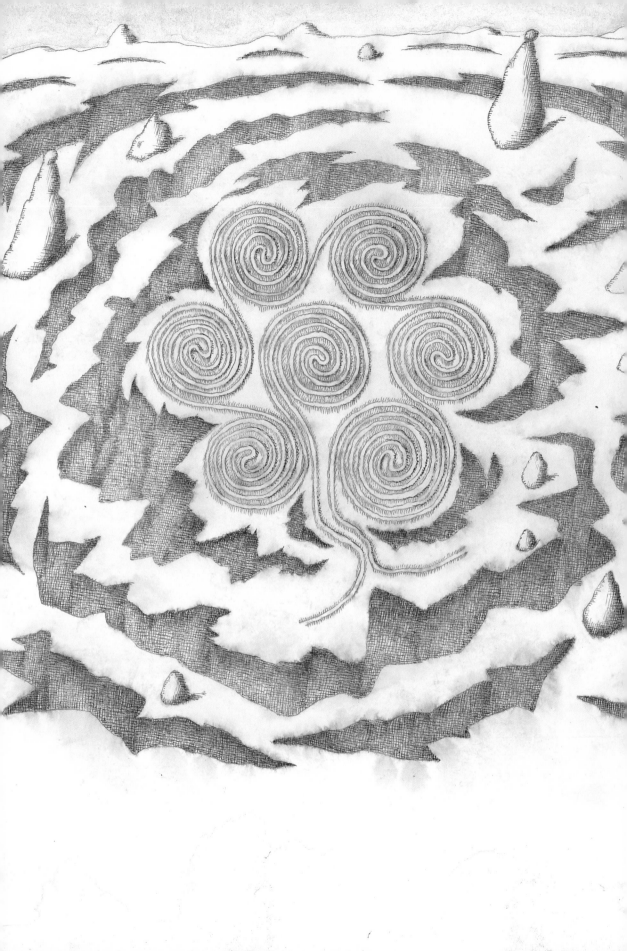

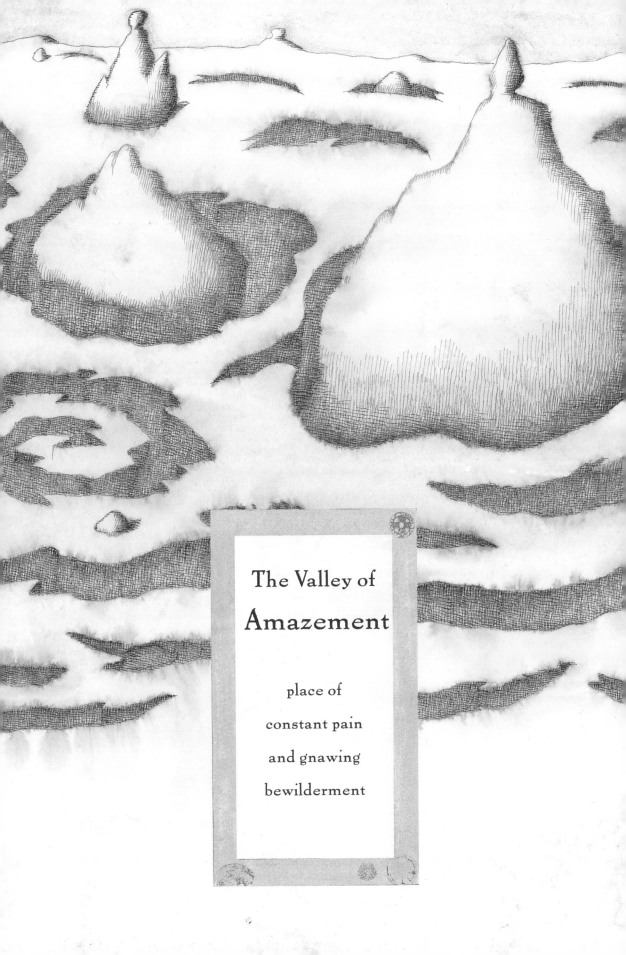

The Valley of

Amazement

place of

constant pain

and gnawing

bewilderment

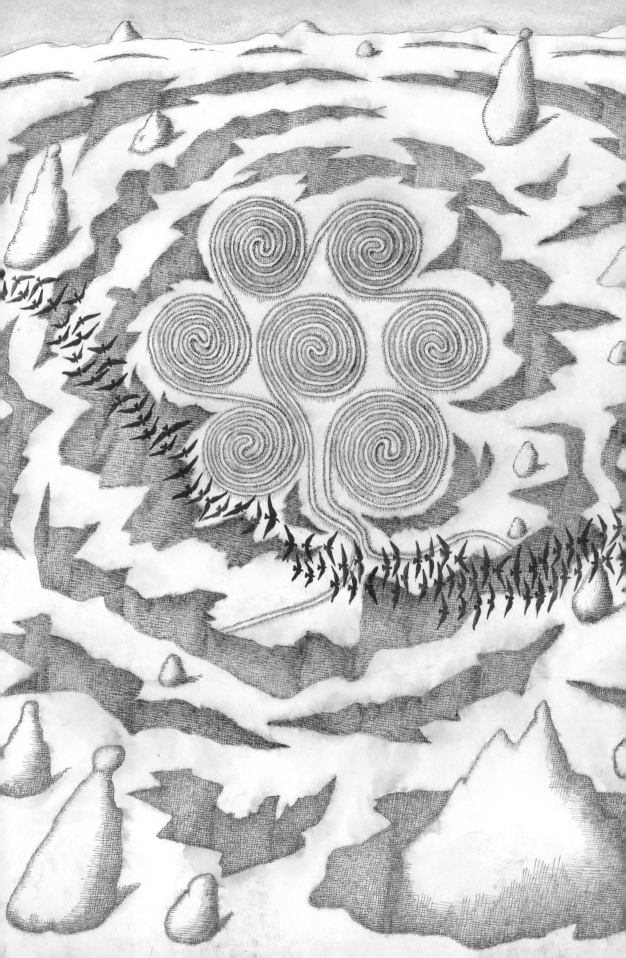

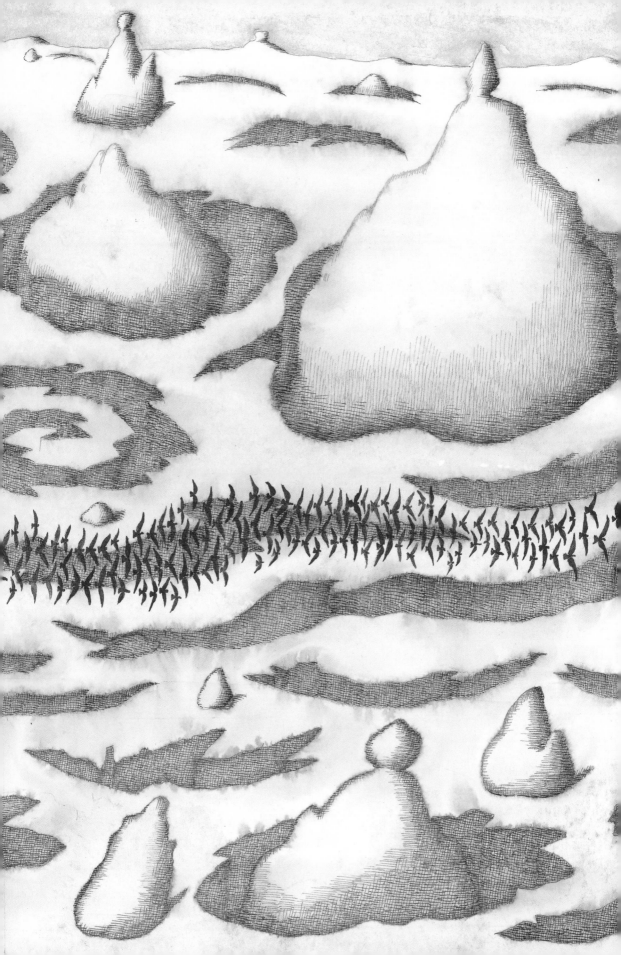

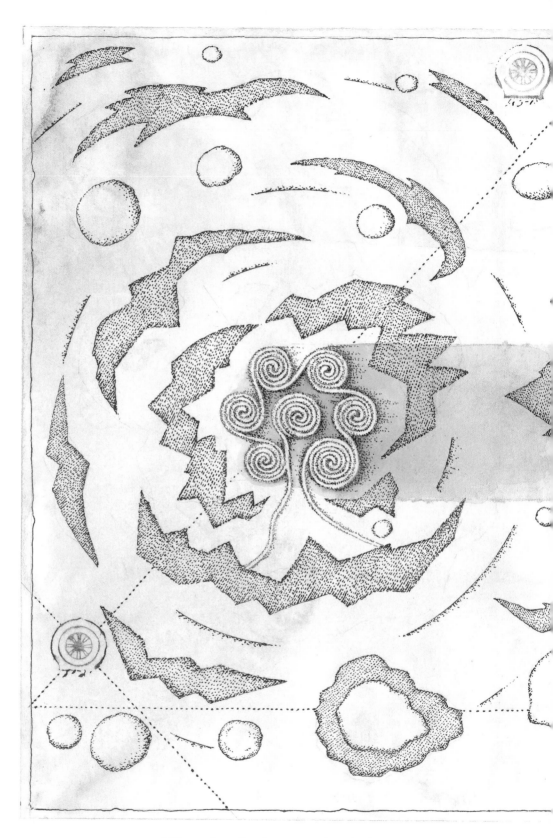

You don't dare to look here...you don't

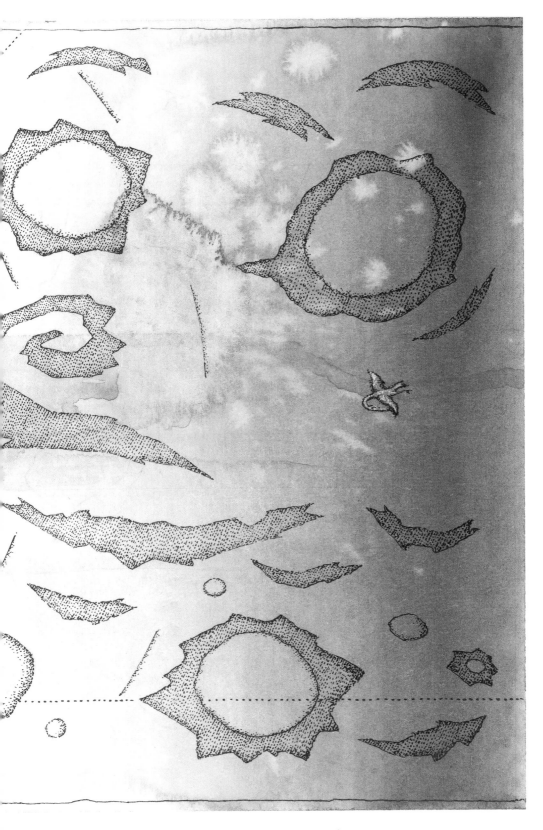

dare to breathe...piercing swords of pain.

When the birds came to the sixth
valley, it disappeared beneath their
wings. They were confused...
uneasy.
They wondered...they waited.

The sorrow bird: We've gone too far.
I'm afraid we can't go back.

Hoopoe: Back?…There's a circle, bird.
Why, just think of the phoenix. He lives
alone for more than a thousand years acquiring
great wisdom and when it's his time to go,
he gathers leaves around himself, spreads his
wings, and starts a fire—a new phoenix is born
from his ashes. We're going forward, bird!

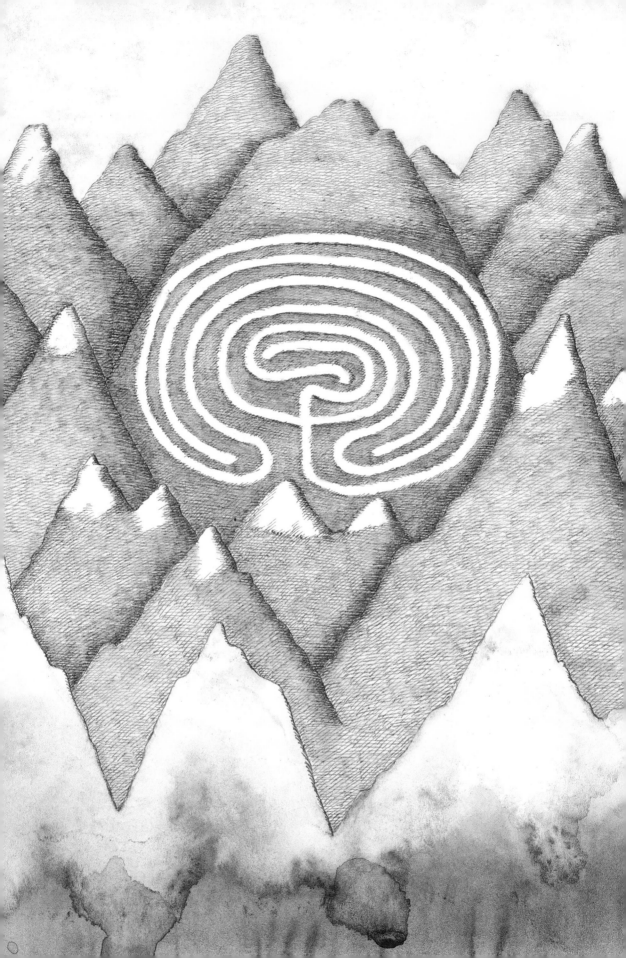

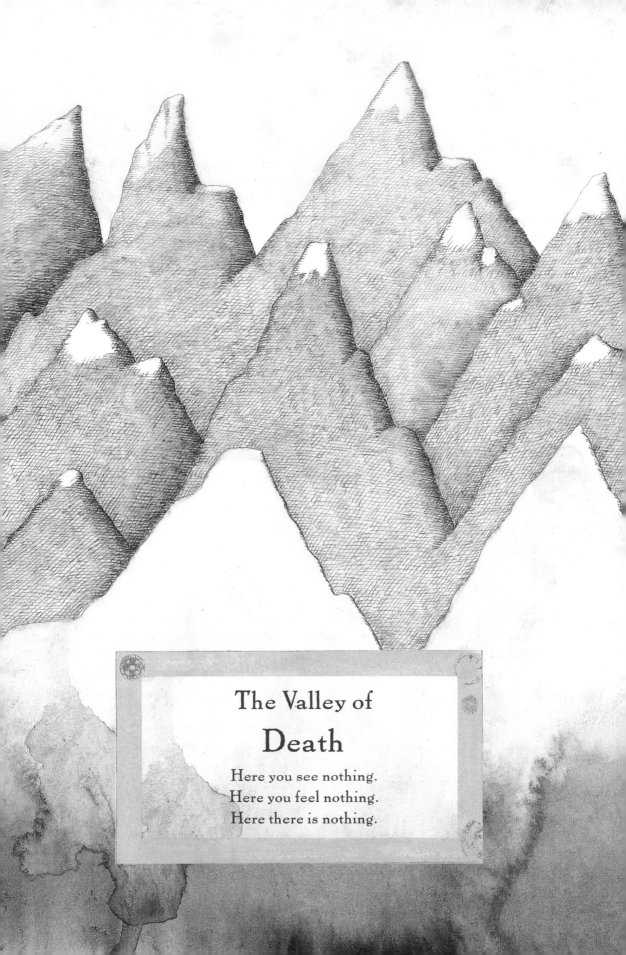

The Valley of
Death

Here you see nothing.
Here you feel nothing.
Here there is nothing.

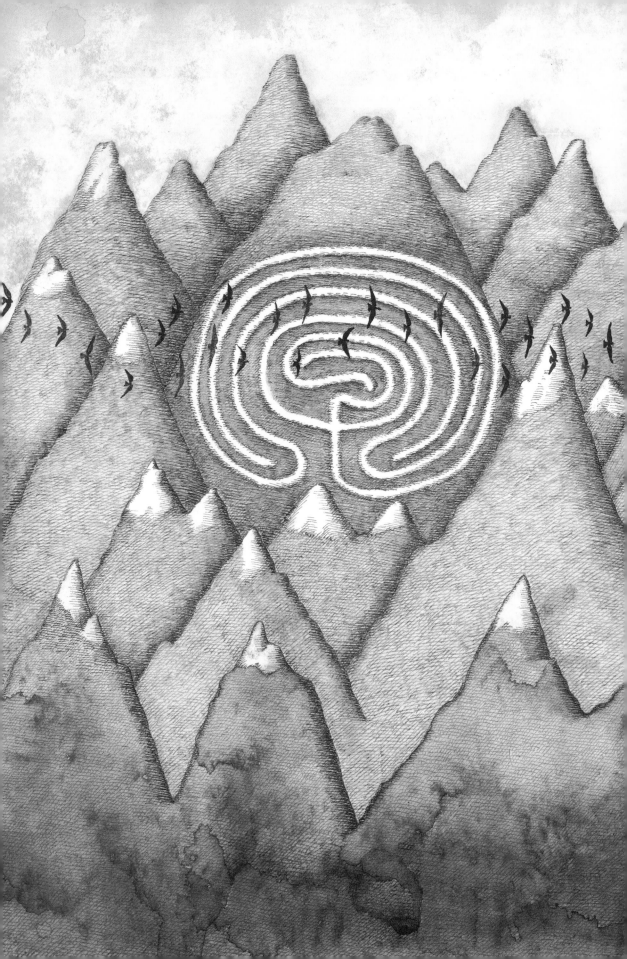

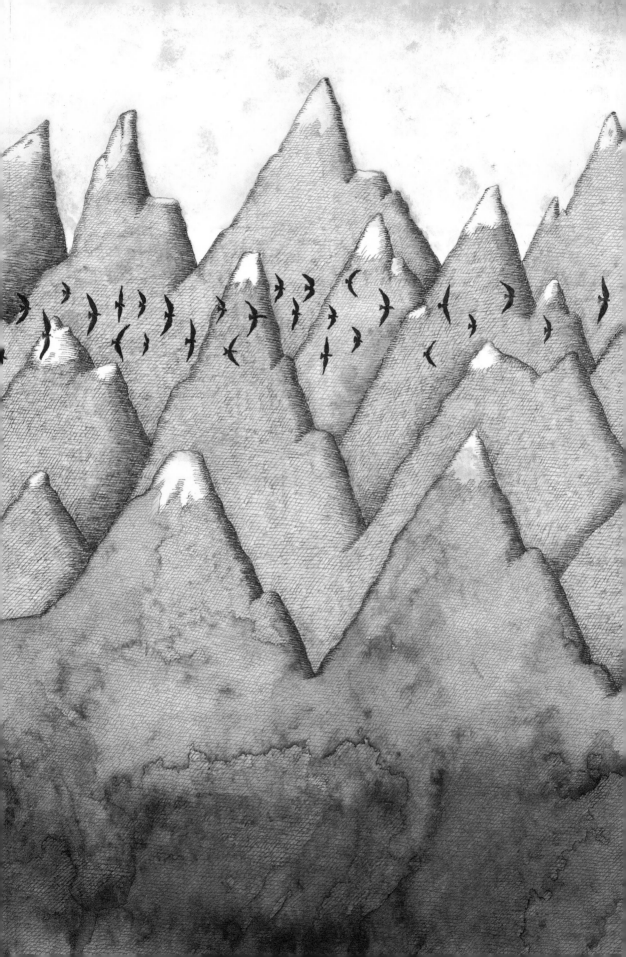

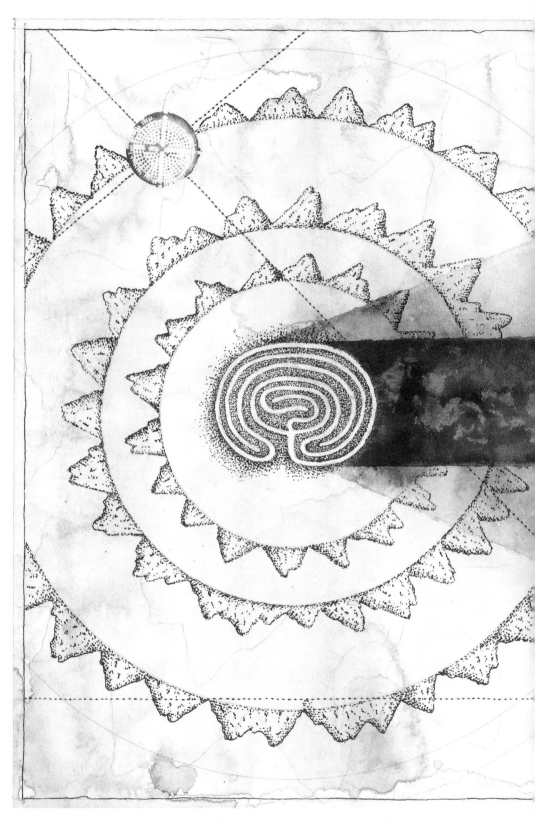

The heart here is still and quiet...

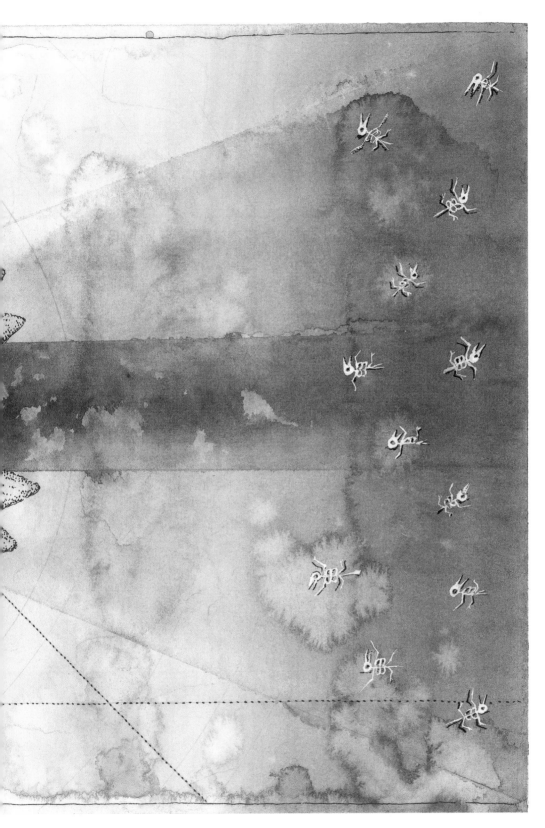

holding many a mystery.

Hundreds of thousands of birds had set off on the journey
and they filled all the corners of the world.

But many didn't make it. Some, distressed and discouraged,
snuck away in fear. Others kept on going but were overcome.
They lost direction, reason, died of thirst, of hunger, from the
heat of the sun, from the vastness of the oceans...

They were ravaged by beasts and scared out of their minds
by what they saw along the way.
Finally, the remaining ragged birds came to the end
of the seventh valley.

BIRDS

Are we alive or dead?

Where is that king

with all the answers?

We've come all this way.

Let us see him!

We made it through

all those valleys!

HOOPOE

Valleys?

They were only

an illusion, birds, a dream.

We've been through nothing.

We are just now

at the beginning

of our journey.

Some birds could not believe it. On the spot, they lost all hope.

Some kept flying.

They dropped dead and fell from the sky.

Part V

In which the
mountain of Kaf
appears in the
distance.

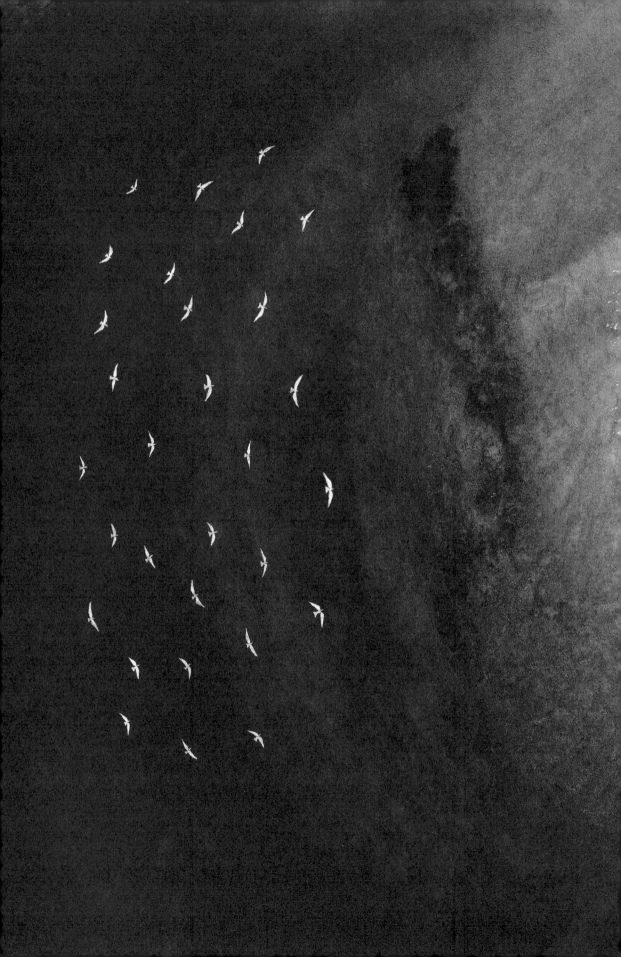

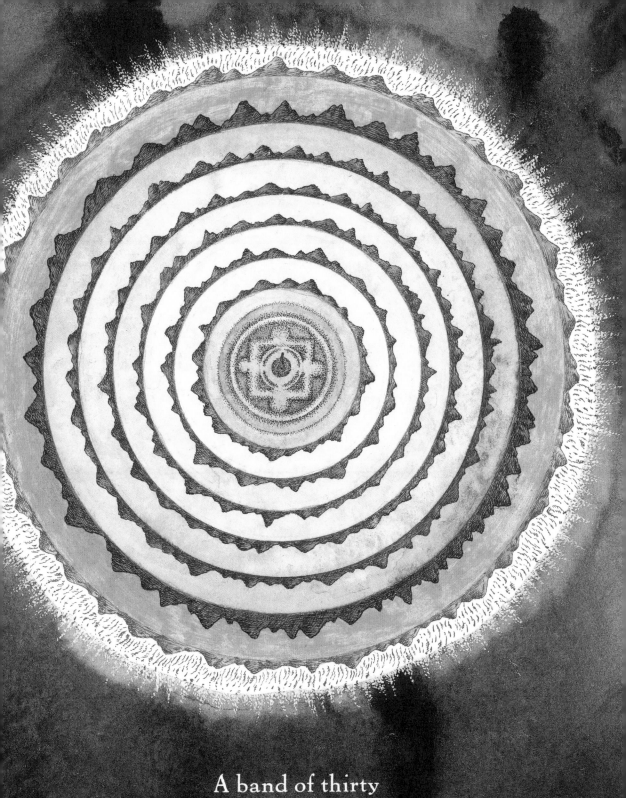

A band of thirty

battered, beaten, beleaguered companions

trying hard not to try and hardly able to fly...

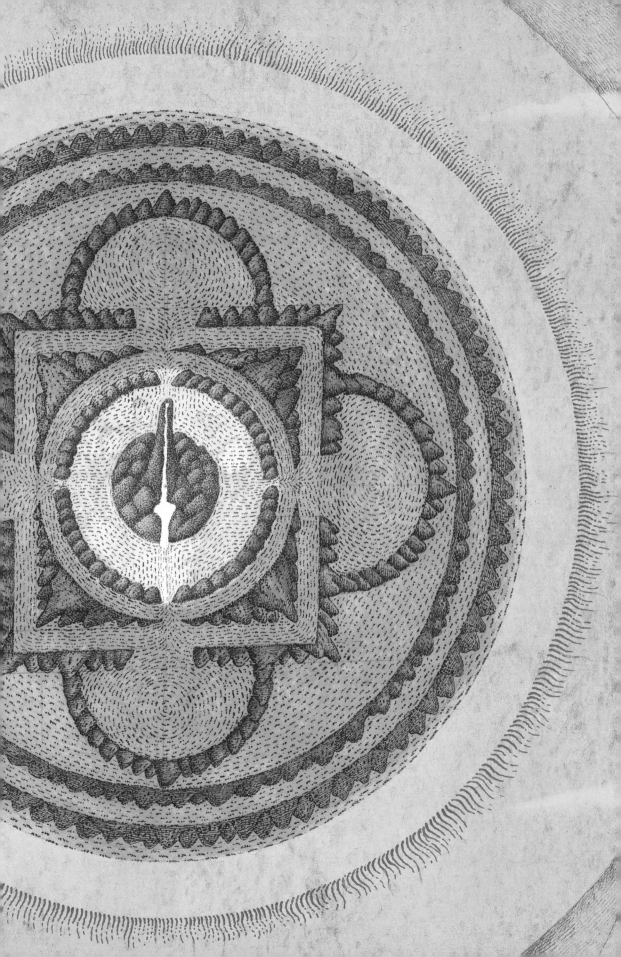

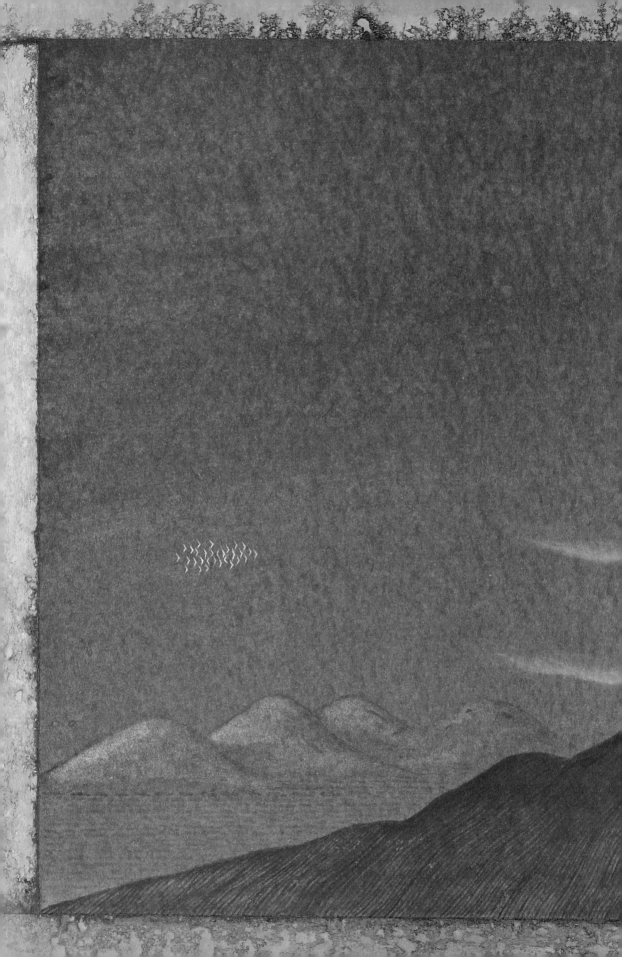

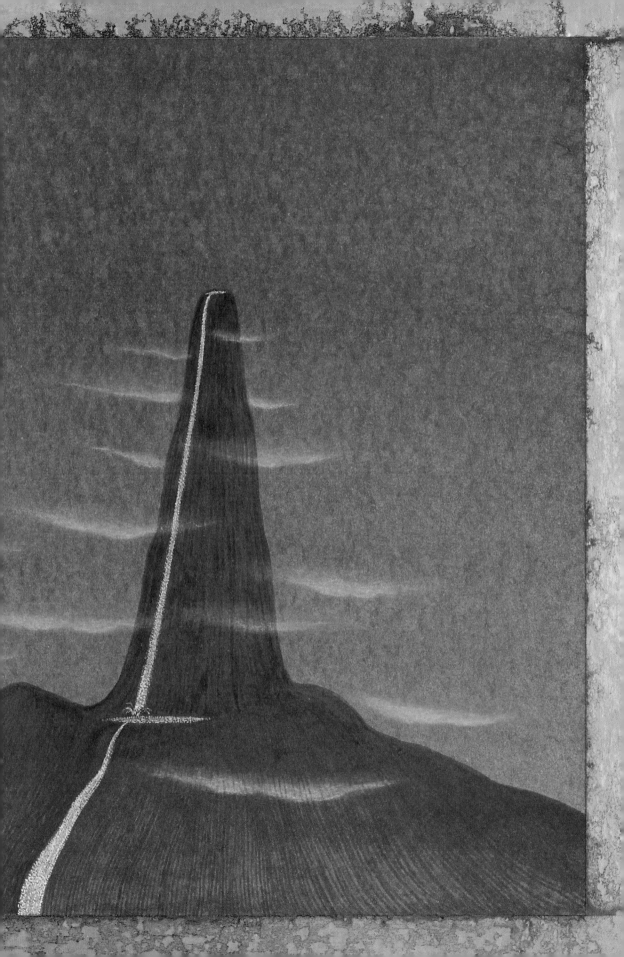

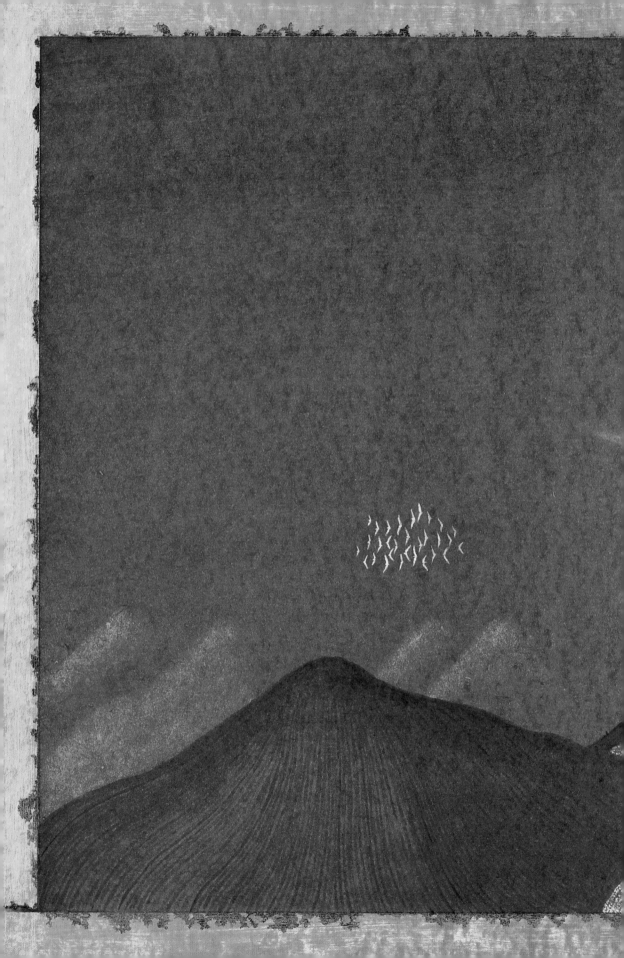

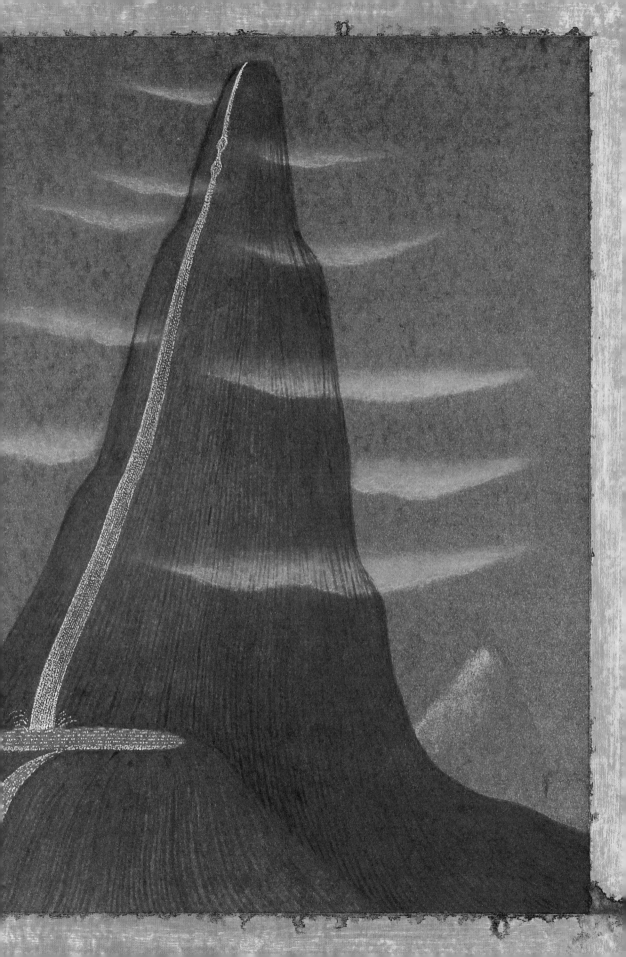

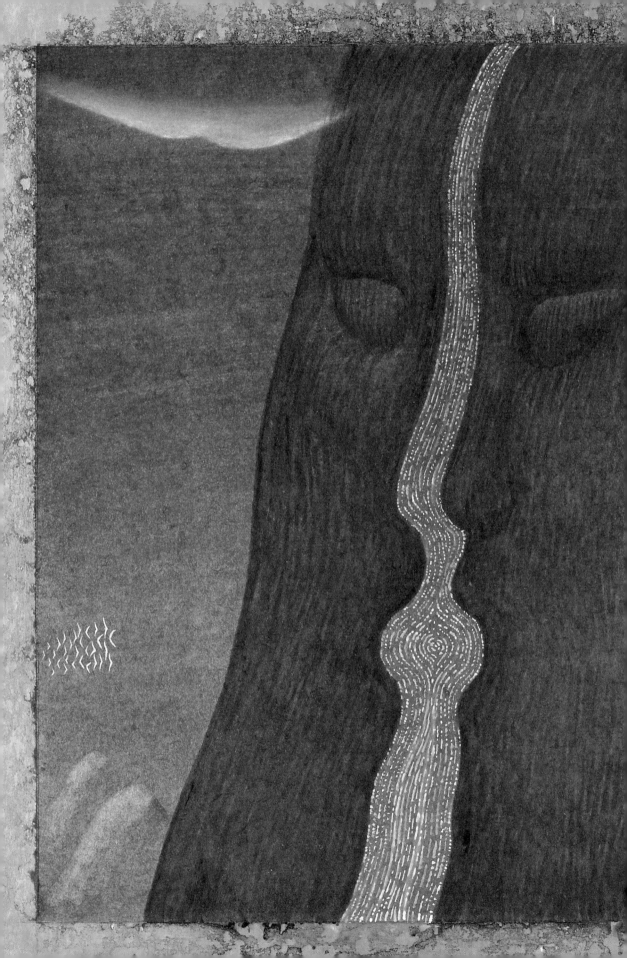

Mountain of Kaf!

We are looking for Simorgh, our king.

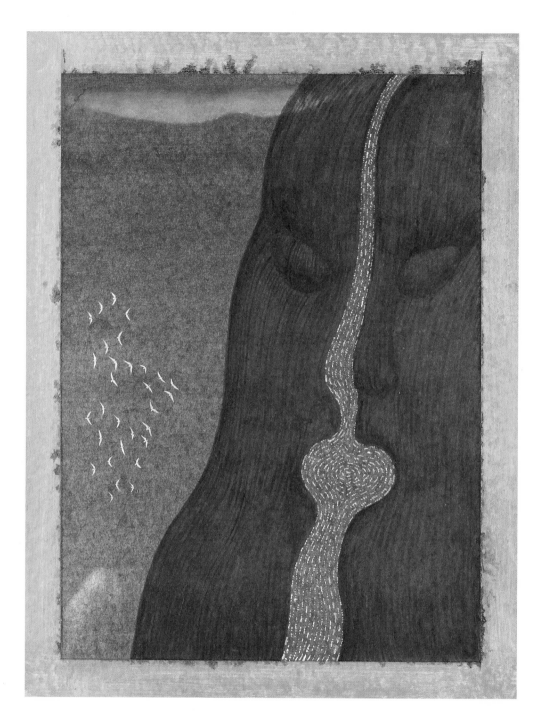

MOUNTAIN

Go home, birds. You are nothing but ashes and dust.

BIRDS

Have pity!

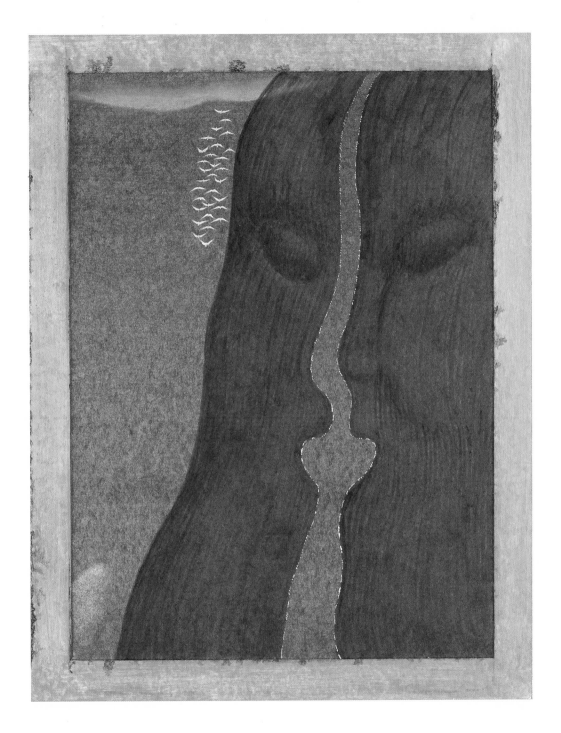

Forgive me, birds. I was fooled by my own illusions!

Are you still there? Come!

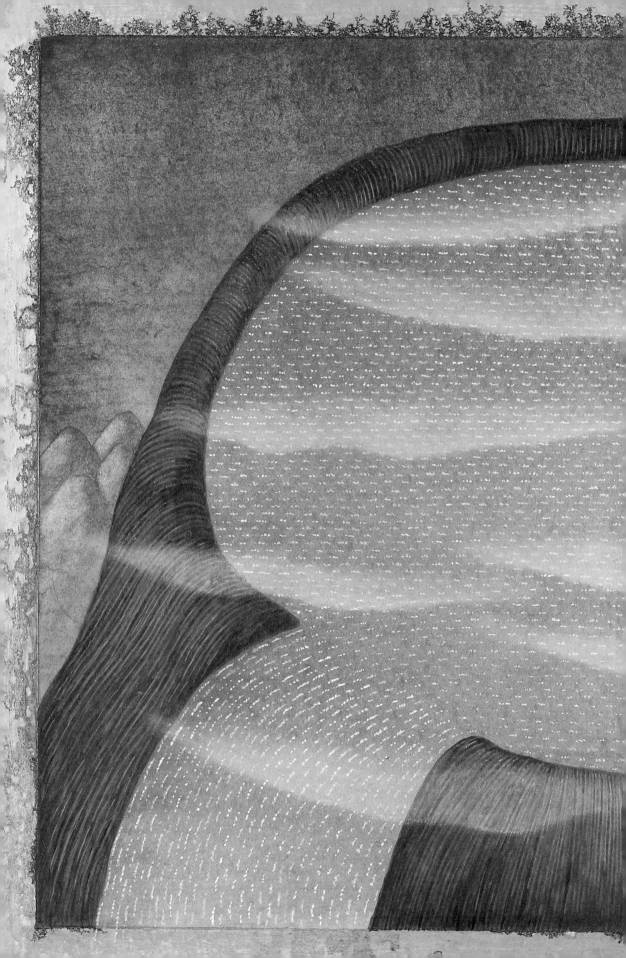

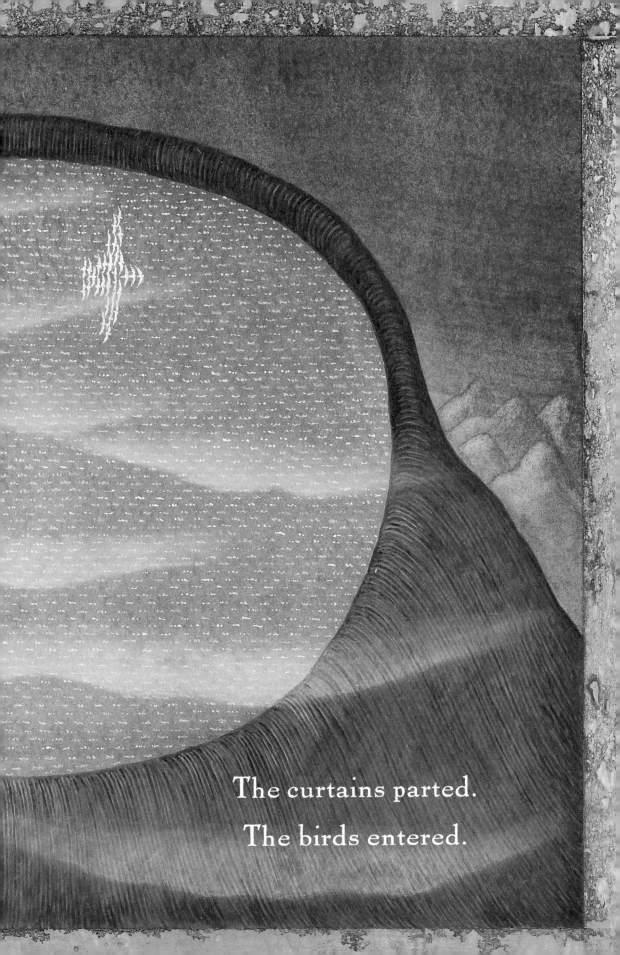

The curtains parted.

The birds entered.

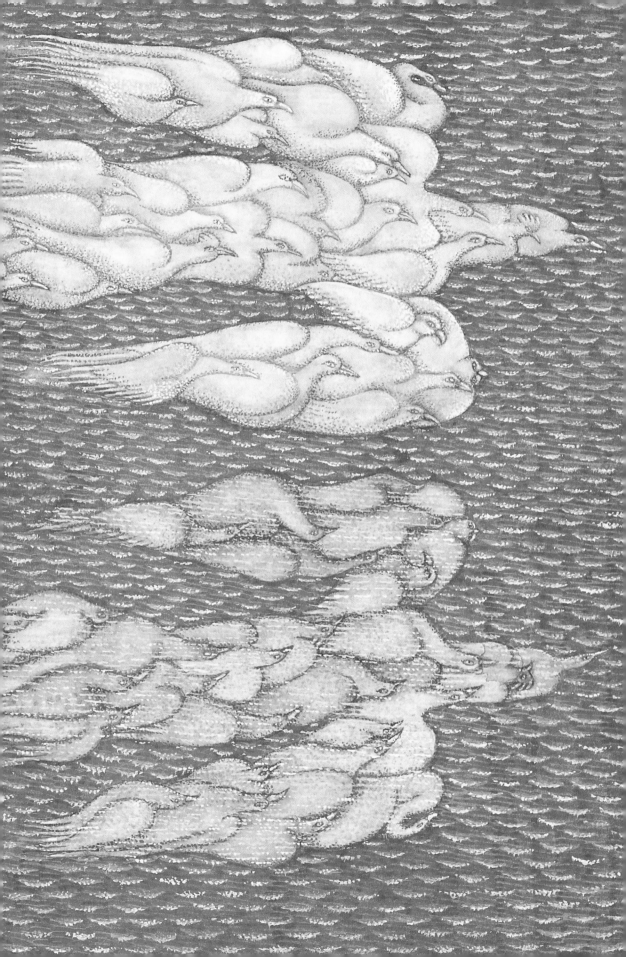

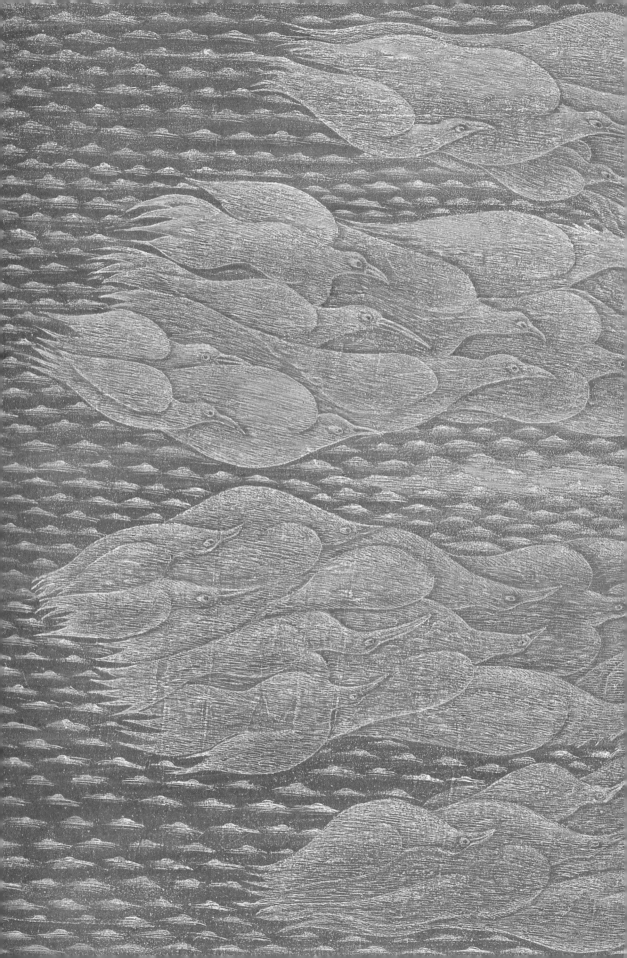

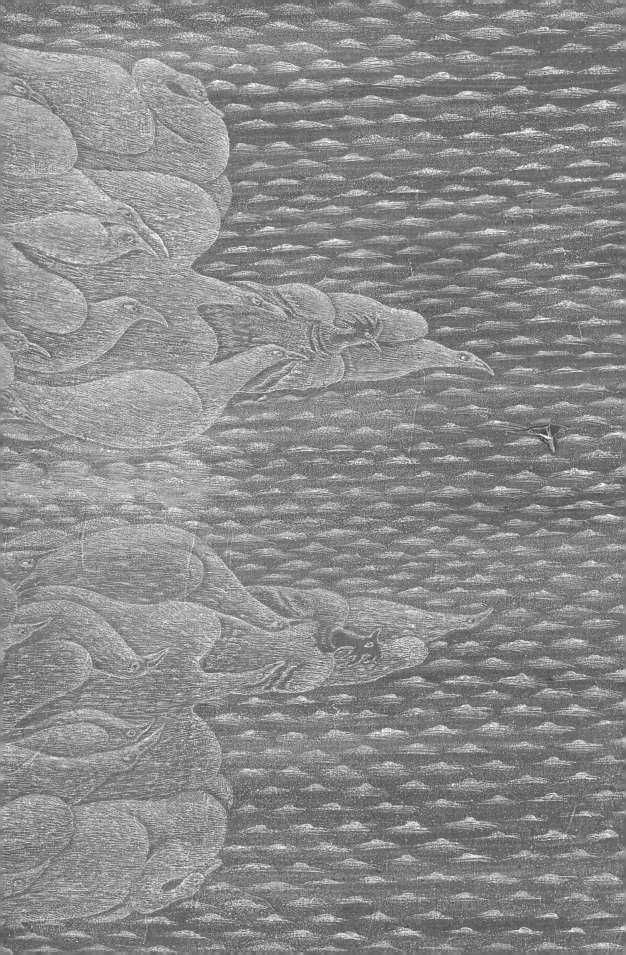

And they saw Simorgh the king

and Simorgh the king was them.

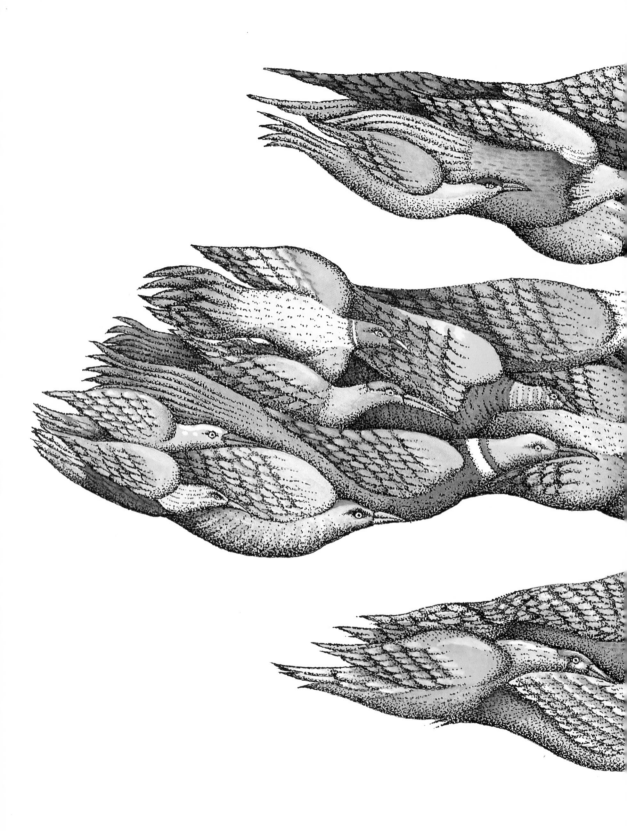

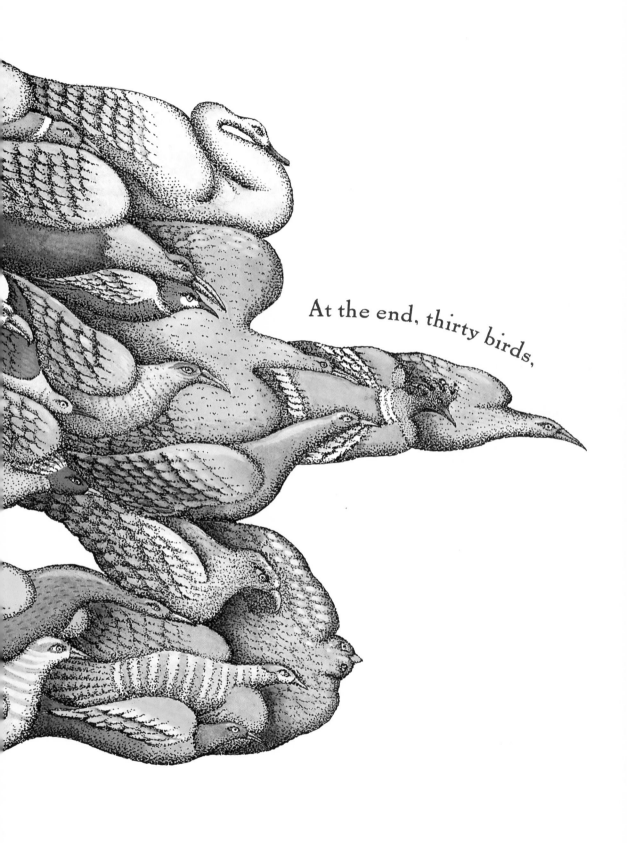

At the end, thirty birds,

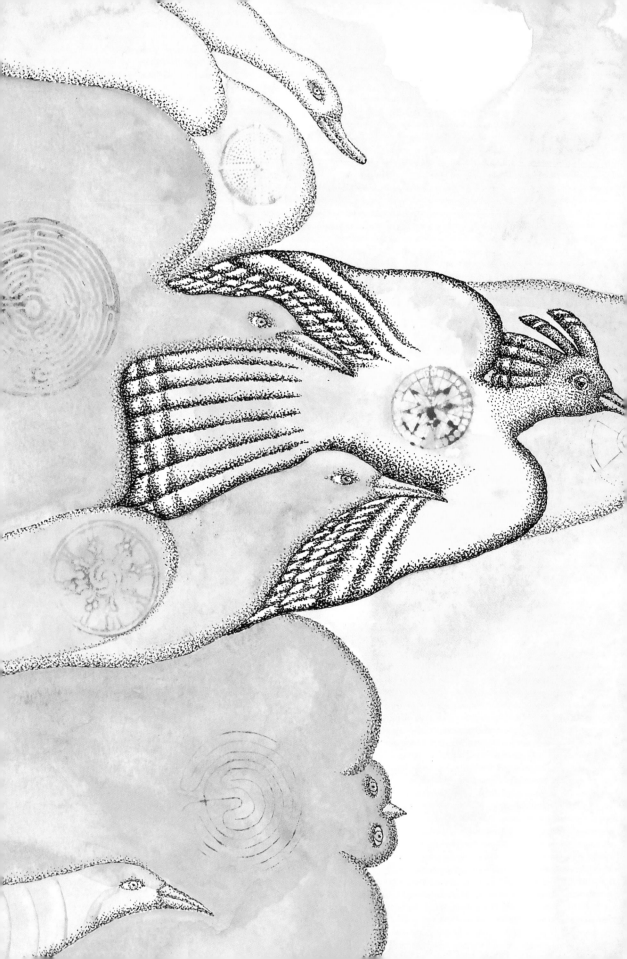

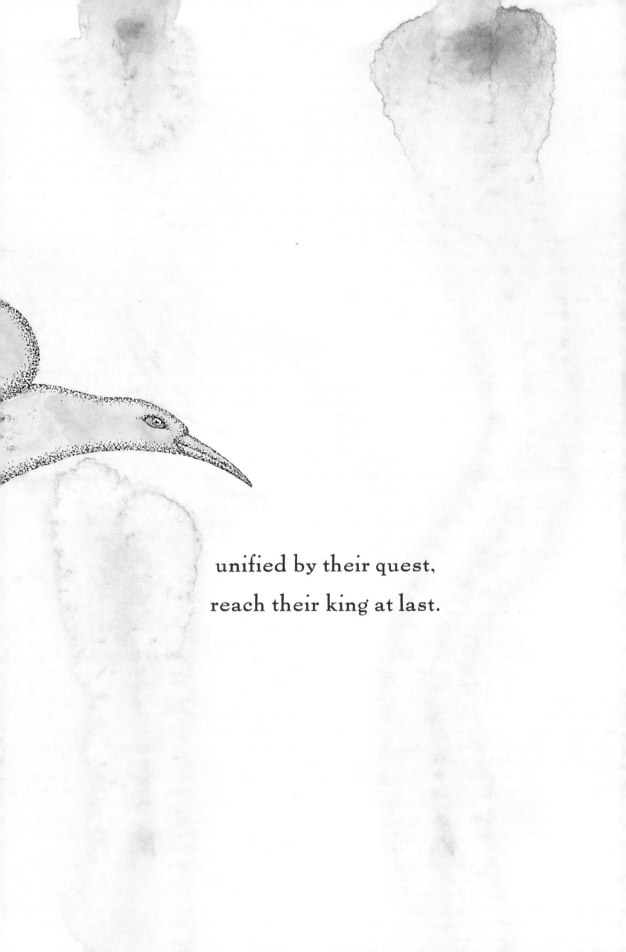

unified by their quest,

reach their king at last.

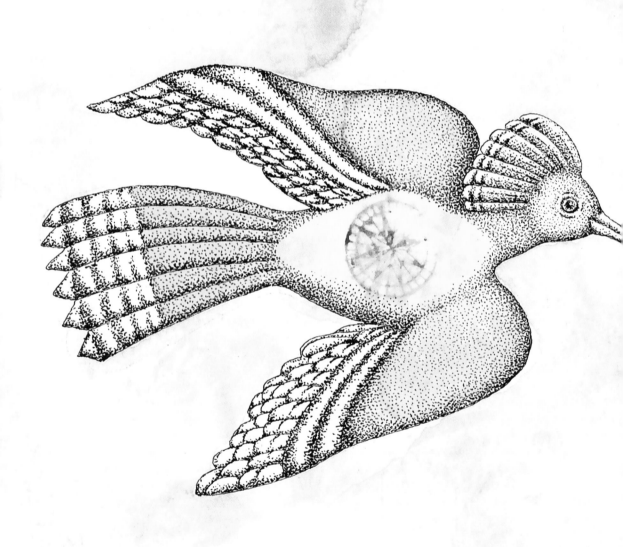

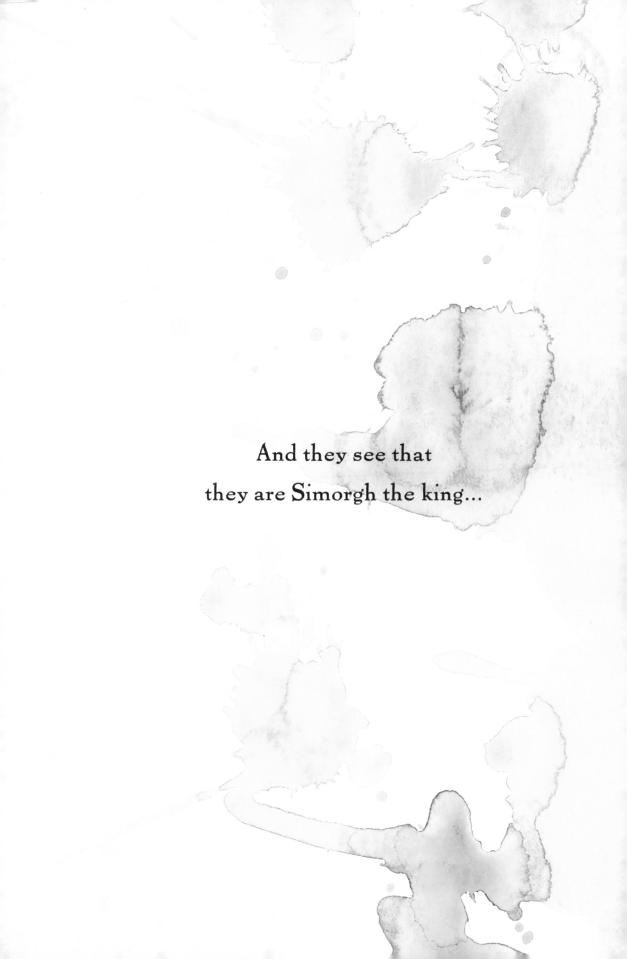

And they see that
they are Simorgh the king...

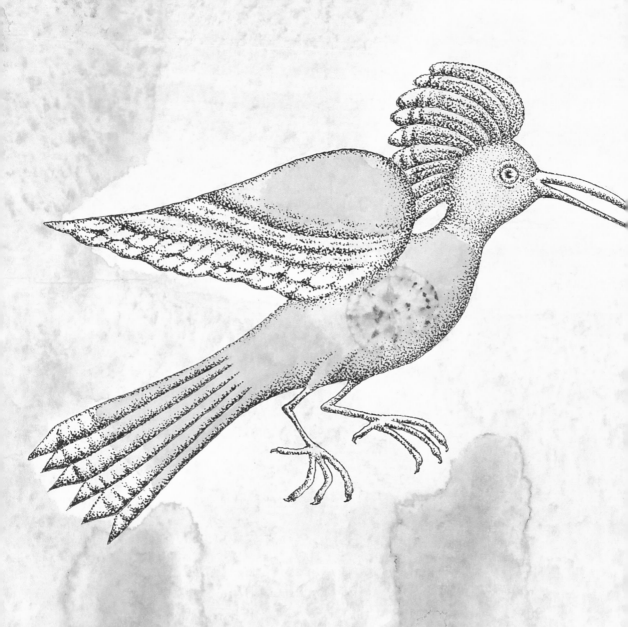

and that Simorgh the king
is each of them...

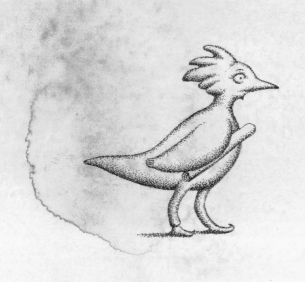

and all of them.

 Peter Sís, recipient of a 2003 MacArthur Fellowship, was born in Brno, Moravia. Today he lives and works as an artist, author, and filmmaker in New York. He has created award-winning animated shorts and films, tapestries, stage designs, and murals. He has written and illustrated a number of books for adults and children, including three Caldecott Honor books: Starry Messenger: Galileo Galilei, Tibet Through the Red Box, *and* The Wall: Growing Up Behind the Iron Curtain. The Tree of Life: Charles Darwin *and* Komodo! *were honored with a Gold Medal from the Society of Illustrators. His art, including three-dimensional works, has been exhibited in Europe, Asia, North America, and Mexico. His latest book,* The Conference of the Birds, *was published in 2011. Peter Sís received the Hans Christian Anderson Award for his body of work in 2012.*

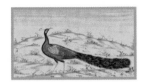 *Little is known about Farid Ud-Din Attar, but the details we're left with suggest a man who challenged the conventions and ideas of his time.*

Attar lived in Nishapur, in northeastern Persia, in the period spanning the late twelfth and early thirteenth centuries. He was known as the Perfumer because he composed his poems in a type of shop-cum-medical dispensary that also sold perfumes. Educated as a theologian, Attar traveled widely: to Egypt, Damascus, and Mecca, and even as far as Turkestan and India. It was said of him that he "never sought a king's favor." In addition to The Conference of the Birds *(also known as* The "Colloquy" [or "Parliament"] of the Birds)*, he wrote a "memorial of the saints" in prose.*

Attar was tried for heresy and banished, his property looted. In the 1220s, he was back in Nishapur, where he died at the hands of Mongol invaders.

THANKS

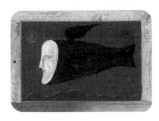 For as long as I can remember, I have loved to draw pictures of flying—freedom—and birds. All kinds of birds: human-face birds, fish birds, snake birds. I used them in my animated films, posters, record covers, and illustrations. The story of Simorgh, which I illustrated in Jorge Luis Borges's Book of Imaginary Beings, was an inspiration. It led me directly to the translation of the original (1177) Manṭiq'ṭ-Ṭair by Farid Ud-Din Attar. In turn, Attar—my hoopoe bird—led me through seven valleys of my own:

In the first valley I read Dick Davis and
Afkham Darbandi's translation of Attar's 4,500-line epic poem.

In the second valley Zuzana Křížová
shared with me her knowledge of all things Persian.

In the third valley my friend and mentor Miloš Forman mentioned
that he had seen an amazing play, based on the poem,
by his friend Jean-Claude Carrière and Peter Brook.

In the fourth valley Scott Moyers set my birds on an unerring course.

In the fifth valley Ann Godoff welcomed them.

In the sixth valley Claire Naylon Vaccaro shaped their world.

In the seventh valley Veronica Windholz gave my birds a song.

Now I hope to get to the mountain of Kaf—and I hope that it is as relevant today as was Attar's masterpiece centuries ago.

INSPIRATION

Farid Ud-Din Attar. The Conference of the Birds.
Translated by Dick Davis and
Afkham Darbandi. New York: Penguin, 1984.

Farídu'd-Dín' 'Aṭṭár. The Speech of the Birds [Manṭiq'ṭ-Ṭair].
Presented in English by P. W. Avery.
Cambridge: The Islamic Texts Society, 1998.

Jorge Luis Borges. The Book of Imaginary Beings.
New York: Viking, 2005.

Jean-Claude Carrière and Peter Brook. The Conference of the Birds
[stage version, based on the poem by Farid Uddi Attar].
Chicago: The Dramatic Publishing Company, 1982.
"Love loves difficult things" (page 47 of this work) is quoted,
with grateful acknowledgment, from Carrière and Brook's play.